CONTENTS

MASTERPIECES OF INDIAN PAINTING

FROM THE FORMER COLLECTIONS

OF

NASLI M. HEERAMANECK

INTRODUCTION, TEXT AND BOOK DESIGN
BY
ALICE N. HEERAMANECK, PUBLISHER

The decorative tracings are from miniatures, Plates 3, 101, and 195.

Text and design by Alice N. Heeramaneck.

First published in the United States by Alice N. Heeramaneck.

ISBN: 0-9602254-2-0
ISBN: 0-9602254-3-9 (paperback)
Library of Congress Catalogue Card No.: 83-82310

Colour separations by A. Mondadori Editore, Verona, Italy.

Printed and bound in Italy by A. Mondadori Editore, Verona, Italy.

TO NASLI

FOREWORD

In the literature of art the word "collection," referring to that of a dealer, is used for works of art that passed through his hands as well as those he retained for his personal use and pleasure. In this series of publications the term includes a type of subcollection that is quite unusual in the annals of art exchange—one assembled and perfected over many years and held inviolate to be disposed of eventually only as a unit. The following notes concern one such collection and the singular motivation of the collector in creating it.

More than 2500 works of art at the Los Angeles County Museum of Art were collected by Nasli M. Heeramaneck. Their present and future accessibility to scholars and the public is the result of a dream that was more than four decades in planning and realization. With the objective of advancing American understanding of the peoples of Asia, their values, motivations, and beliefs, Nasli Heeramaneck sedulously pursued, acquired and set apart masterpieces of Asian art from the Mediterranean to Mongolia with emphasis on the two cultures, Indian and Iranian, to which he as a Parsee was heir. His goal was the formation of several collections, each specialized in an area or epoch of distinctive cultural achievement of central and western Asia, that he hoped to combine in one museum. Just at the time he began to consider which institution might be the the most receptive and appropriate, the Los Angeles County Museum of Art initiated a program of expanded acquisitions for its new building complex. The Museum's permanent collection had a sampling of the major areas of the history of art, but no area of great strength. The Heeramaneck Indian, Nepalese and Tibetan collection offered the opportunity for just such a specialization. Its acquisition in 1969 brought to the Museum 345 works of art each chosen for its notable conception, craftsmanship, and aesthetic quality. The nucleus is a brilliant panorama of Indian art from the Indus valley settlements to the Mughal courts: monumental stone sculptures, bronzes, paintings, textiles, and jade and crystal luxury objects, many of them reproduced in this and the preceding volume of this series. Hardly less impressive is the comprehensive section of exuberant religious art of Nepal and Tibet: painted votive banners with a plethora of gods and goddesses, Buddhas and Boddhisattvas, sages and monks; illuminated manuscripts; sculptures in bronze or copper, usually gilded, often polychromed and adorned with jewels; and exotic ceremonial objects—the subjects of the third volume in this trilogy.

The immediate result of the acquisition was that the Los Angeles County Museum of Art with only a token handful of Indian pieces was catapulted into being, along with the museums of Boston and Cleveland, one of the three leading centers of Indian art in the country and one of the five in the western world. In Nepalese and Tibetan art it became first in the nation. This meant that it immediately drew the recognition and frequent visits of scholars, collectors, and devotees of Indian art from the rest of the world, including India. To the Museum's patrons, trustees and staff it opened vistas that stimulated a vigorous and enthusiastic expansion of the Asian collections. An essential part of that program was the acquisition of the second and third portions of the Heeramaneck collection. The art of Islam, acquired in 1973, consisted of 650 paintings, calligraphic designs, ceramic tiles and utensils, glass, metalwork and textiles from Persia, Turkey, Egypt, Syria, Mesopotamia, and the farther reaches of Muslim cultural domination—an art of glowing color, rhythmic design and poetic adaptation of natural forms. This was followed in 1976 by the art of ancient Iran and Central Asia: 1500 works, mostly small bronzes of the nomadic herdsmen and early agriculturalists of the Bronze

and Iron ages from Europe across the mountains and steppes of the Near East, South Russia, Siberia, and Central Asia to Eastern Mongolia. These acquisitions, along with that of the Indian, Nepalese and Tibetan collection, initiated an expansion of Asian research and publications, including the first comprehensive catalogs of the Islamic and ancient Iran and Central Asian collections, and evoked a greatly augmented demand for lectures and seminars at the Museum, new courses at the universities from Santa Barbara to San Diego, and more books on Asian subjects at the public libraries; in short, they elicited a deepening consciousness of Asian cultural accomplishments, just at the time Asia and the United States, especially the West Coast, were entering a new historic phase in economic and political relations.

Nasli's motivation in forming this extraordinary tripartite collection is deeply rooted in his Parsee rearing in Bombay. It was his father, who in conformity with Parsee tradition was responsible for the guidance and education of his son, to whom Nasli gave credit for having made the greatest contribution to the collection as well as to his perspectives on life and human relations. Munchersa Heeramaneck, a dealer in Chinese ceramics and Indian sculpture and painting, transmitted his love, knowledge, and connoisseurship of Asian art to Nasli and inculcated in him Parsee standards of ethical responsibility and behavior. The essential principles of Zoroastrianism, brought by the Parsees from Iran when they migrated to India in the eighth century, are the identification of the individual with family and community and the attainment of virtue through good thoughts, words, and deeds, especially the latter. The highest virtue is not found in retirement from the world as in Buddhism, Catholicism, and many other religions, but in full participation in contemporary life. Business success is held in esteem if accompanied by moral success, achieved through integrity in professional performance supplemented by deeds that are "selfless and for the good of mankind," especially charitable and educational ones. Such acts of public beneficence are attributed to good rearing and reflect special credit on the parents.

In accord with the foregoing principles, Nasli projected the formation of the collection as a virtuous Parsee deed to which he contributed forty years of his knowledge, acquisition skills, and connoisseurship. The immediate impact of the collection on Southern California provides sufficient evidence of its humanistic and social value to qualify the deed as being, in the Parsee phrase, "for the good of mankind and the progress of the world." To Nasli the collection, supplementing his distinguished career as an art dealer, brought self-realization and a unity of professional and moral life along with the gratifying assurance that it would, indeed, bring lasting honor to "his father, his family, his community, and his country" and continue to contribute to American cultural life and international understanding.

KENNETH DONAHUE
Director Emeritus,
Los Angeles County Museum of Art

ACKNOWLEDGEMENTS

It has been my intention in the preparation of this book to present those paintings to which my husband, Nasli Heeramaneck, was most attached, arranged as though seen in an exhibition which he might have prepared. To Nasli, the placement of objects to which he was deeply attached into meaningful collections and finally to succeed in placing them in institutions where they could remain forever for the public to enjoy was the most happy and constructive activity of his life and it was that which gave him most joy. So it is my hope that this assemblage of reproductions will bring the viewer the pleasure which he had hoped they would.

I have limited myself to the purely aesthetic aspect in an attempt to evoke the pleasure that may be derived from these small paintings leaving the complexities of the subject matter to those many fine writers who are far more competent for the purpose than myself. For an insight into the mysteries of Krishna, "The Dark One," so often the subject of the Rajput painting in this book, I would refer the reader to the poetic and revealing "Essay" on the Krishnamandala by Walter Spink, listed in the Bibliography.

For a glimpse into the Gupta period, *The World of Courtesans* by Moti Chandra was a necessity, and for an understanding of Indian painting in the classical and post-classical periods, *South Indian Painting* by Sivaramamurti was invaluable. I would not have known how to turn without *Indian Painting* by Basil Gray and Douglas Barrett or *The Arts of Mughal India* by Cary Welch or *The Grand Mogul* by Milo Beach.

In this brief foreword I wish to express my deepest gratitude to the many art collectors and institutions who have permitted me to publish paintings which are now their property, and I also wish to thank the many scholars who gave me much advice and help: Mr. Milo Beach for his invaluable assistance in the preparation of the captions, also Anand Krishna who contributed valuable information, as well as Cary Welch who was ever ready to come forward with advice and suggestions. But most particularly I am indebted to Mr. Basil Gray who reviewed the entire text of this book, making many very needed corrections along with much assistance and information.

Last of all I wish to pay tribute to Dr. Ananda K. Coomaraswamy who was the first scholar of world renown to write with feeling and understanding of Rajput painting.

HISTORICAL INTRODUCTION
INDIA'S ANCIENT PAST

In this introduction an attempt will be made to trace the background of painting in India from earliest times as it would seem increasingly evident that neither the Rajput nor Mughal school could have come into being without it in spite of all the various influences from outside India which assisted in their formation.

Painting in India almost certainly existed in the prehistoric past as it did in other ancient centers of civilization such as Egypt, Crete, the Near East, Mesopotamia and Syria, from which areas archaeology is continuing to make discoveries, giving evidence that these areas already traded with India in the third millennium B.C., a time when India, it appears, enjoyed a highly developed, extensive and extremely wealthy empire.

India in the third millennium B.C.

Great periods in art may be said to result not only from the patronage that political stability and surplus wealth can supply, but to be brought about by the coming together of that fortunate blend of internal and external factors which may succeed in creating a high point in human expression. Although fads in taste and even aesthetic judgement may come and go, in Europe the larger view will never leave out the art of the Renaissance nor the world of Greece and Rome. But in India it was the period of the Gupta empire which brought about a golden age in all the arts, also spreading its humanistic grace to the lands of Southeast Asia where Indian merchants had set up kingdoms from the beginning of our present era. With the crowning of Chandra Gupta in 32 A.D. to the invasion of the White Huns in the sixth century, with a brief revival taking place under King Harsha whose reign has been made famous by the Chinese travelers to India in the seventh century, an age of the greatest cultural activity came about.

The Gupta period.

India had never enjoyed greater wealth, trading with Rome from the first century A.D., perhaps even receiving a few artists from that great empire who may have sought out the fabled wealth and patronage which they had heard existed to the East. We learn from Roman writers of the government's complaint that gold was flowing in that direction to pay for the luxuries of Roman ladies and, as archaeology has revealed a Roman trading post in the South, the influence of Rome is hard to doubt. Therefore it may be assumed that the combination of Roman naturalism coming in contact with the pre-existing painting of India[1], assisted by extraordinary wealth and patronage, brought about the classical style of the Gupta era. From developments that took place in both painting and sculpture an ideal of the human form was realized, sensuous though spiritual and infinitely harmonious, which was never surpassed in that part of the world in any other period.

Trade with Rome.

The best known examples of painting in the Gupta age[2] are to be seen on the walls and ceilings of the temples and monastery halls carved into natural caves around cliffs surrounding a gorge at Ajanta, the finest belonging to the sixth century. Painted on dry plaster, these examples have been considered by some to carry the art of wall decoration further than any other yet known to the ancient world. Drawn with facile realism, all the forms and shapes whether human, architectural, floral or animal, are deliberately composed and designed to fit and decorate a given space. Although perspective is suggested, it never penetrates the wall surface, and the groups of figures are bound together in a continuous line of deeply rhythmic purpose. Here gentle and spiritual Buddhas, Boddhisattvas and gracefully swaying female figures are masterfully arranged against palace architecture with tree and plant forms, exhibiting a fine sense of design in depth with a line capable of expressing weight and content, foreshortening and a degree of perspective. Although great wall painting and decoration existed in the much earlier past and undoubtedly graced the walls of wealthy Greeks and Romans, the known specimens are more or less illusions of what casually meets the eye, however charming the results may be. One has only to observe the Boddhisattva

Ajanta frescoes.

Compositional design of the Ajanta frescoes.

seated with his Female Followers with the Sacrifice to Dionysius from Hercula-neum in the National Museum, Naples, to understand the design-motivated character of the one as opposed to the illustrative purpose of the other.

Beautiful square compartments are also to be seen painted on the ceiling which are filled with floral arabesques that are entwined with animal gnomelike figures, their limbs ending in trailing plant forms gracefully filling their allotted spaces with a most delicate line. Although not be seen in anything but the dimmest light, the colours of these frescoes are in rich and harmonious earth tones. Floral arabesques seen in Ajanta ceilings.

Equally beautiful wall painting is to be seen in a fragment from Sigiriya, Ceylon, of the sixth century. Here a row of female figures advance singly and in pairs, the lower portions of their bodies lost in clouds, which apparently decorated the walls of what once constituted the private halls and galleries of King Kasapa. These exceedingly graceful and slender divine ladies are drawn with consummate skill in a strong revealing line with inner modeling to enhance the soft voluptuous effect and are perhaps as effective as any painting known from India. Sigiriya, Ceylon.

Although painting in India was widely practiced in the Mauryan age, third century B.C., with instructions on painting dating from that period, no visible paintings survive from that era except for Cave 10 at Ajanta where very fragmentary remains exist which Sivaramamurti[3] places in the second century B.C. These fragments show that the style of the sixth century was already in process of development at this much earlier time with the human features and bodies well realized, also painted in a similarly rich earth colour palette. The turbans, costumes and body postures in these early fragments resemble the bas-reliefs of Bodhgaya, also of the second century B.C. and seem related to Gandhara as well. Painting in the Mauryan age.

Innumerable references to painting on walls, boards, palm leaves and canvas are to be found in *The World of Courtesans*[4], a most informative book compiled by Moti Chandra from various Sanskrit texts dating from the Mauryan and through the later medieval periods. According to Kautilya's report in the Arthasastra, which describes in detail various facets of the Mauryan state, the *Ganika,* the highest ranking courtesan, whose profession descended in categories to the ordinary whore, was the property of the state. Finding it impossible to stamp out prostitution and realizing its enormous potential for revenue, the state had incorporated the activity under it bureaucratic procedure with innumerable very precise and exact regulations. *The World of Courtesans.*

As beauty and artistic accomplishment governed the income of a *Ganika,* (courtesan), and as that income passed to the state, it in turn undertook to remunerate her and set her up in the luxury and elegance that her high state in the world of entertainment and pleasure required. She was supplied with great mansions and the finest clothing and jewelry, all of which, however, remained the property of the state. The state also made arrangements for her instruction in the various arts; *Ganikas* and actresses were taught ". . . singing, instrumental music, recitation, dancing, acting, writing, painting and playing on the vina, the pipe and the drum," along with skills in the arts of love. *Ganika*—the highly cultivated courtesan.

Moti Chandra reports numerous references regarding the fact that senior officers, rich merchants and bankers regularly visited the courtesans for other than purely amorous reasons. The cultivated conversation of the *Ganika,* her knowl-edge of literature and the arts evidently supplied more than these rich gentlemen might find at home. Again from Moti Chandra, we learn that Vatsyayana in the Kamasutra systematized a considerable amount of material concerning the courtesans and prostitutes in ancient India, and Yasodhara, the commentator of the Kamasutra, presents a long list of arts prescribed for the *Ganika* among which we find vocal music, instrumental music, dancing and proficiency in scripts. They were all required to read and write in more than one vernacular, compose poetry, acquire sympathetic speech, study painting and stucco work (which could signify either wall painting or modeling in plaster), as well as learn, and we quote ". . . stencil cutting from leaves." Stencil cutting.

Stencil cutting was particularly fashionable and the *Nagaraka* (elegant man about town who was a sort of cultivated playboy dedicated to both physical pleasure and the arts) had to be adept in this technique and always carried a pair of scissors attached to his belt. One obnoxious show-off described in a Gupta period play always sported a large pair of shears. This writer believes that the art of stencil cutting never died but was continued through India's long period of submission to Muslim rule when the art would have constituted a most inexpensive source of continuing pleasure. The earliest Rajput paintings are in a curiously sharp and angular style which one can easily see as a result of this stencil cutting practice. This will again be noted in the chapter on Rajput painting.

Nagaraka, the cultivated playboy.

The *Nagarakas* were organized into gentlemen's societies which met periodically, presenting plays, dance recitals and recitations of poetry as well. Prizes were awarded and the *Nagarakas* could truly be said, along with the rulers and wealthy patrons, to be among the pillars of culture in the Gupta and medieval societies.

The cultivated clubs of the *Nagarakas* were organized for promotion of the arts.

Yasodhara supplies us with an interesting list of six basic principles underlying the composition of a good painting: "Forms, proper measurements, emotion, integrating the concept of beauty, realism and proper application of colours." Evidently these prescriptions were framed and set up to inspire the practicing painter which in fact appears to have included any person aspiring to culture. There are many references to a *Nagaraka* sitting in his principal room painting a picture, and on page 57 of Moti Chandra's book, we read a description of how one of these gentlemen, addicted to a life of pleasure, was supposed to live. Along with a most interesting list of furnishings and appurtenances, some for his amorous activities, others describing a sort of workshop for his creative endeavors, we read, " . . . from a peg hung a covered vina on which he played, a wooden panel on which he painted and a box of painting brushes, the palm leaf manuscript of his favorite poem and a garland of flowers which did not fade" (It is interesting to note this early date for the existence of artificial flowers.) " . . . in an obscure corner the *Nagaraka* could busy himself with carpentry and spinning."

Yasodhara supplies us basic principles underlying a good painting.

Mention of artificial flowers in the Gupta period.

Again from this inexhaustible source, *The World of Courtesans,* pages 26-27, we are informed that a famous courtesan named Amrapali, from Vesali, invited painters from all over India to come and paint portraits of kings, ministers, bankers and merchants on the walls of the picture gallery of her mansion as she wished to use this as a basis for selecting her clients. (This reminds one of an album that the great Mughal ruler Akbar had commissioned in the early seventeenth century, about 2000 years later, to contain portraits of all his ministers for a similar reason—"That he might judge of their character.") We learn that she was impressed with the portrait of Bimbisara, famous king of Magadha at the time of the Buddha, and thought he was a man fit to consort with. This she finally managed and bore him a son.

Amrapali, the famous courtesan, selects her clients from her portrait gallery.

Returning to another section of our most interesting source, we are given further glimpses of the cultivated activities of our well-educated young ladies who, on page 109, "are studying sheets from a manuscript" and on page 134, "a half read book is lying on the gaming table . . . and courtesans and elderly libertines . . . wander about holding pictures painted in many colours."

Young courtesans with elderly libertines examine paintings.

Moti Chandra, in quoting from the *Kuttanimatam* by Damodara Gupta, the chief minister of King Jayapida of Kashmir (r. 751-782) gives us a passage which throws an interesting light on Kashmir in the eighth century. The locale is Varanasi, "which was inhabited by metaphysicians and worshippers of Shiva." There also lived courtesans who were surrounded by their lovers. We quote: "The flags fluttered from the high lofty houses provided with balconies. The city was populated with Sadhus (wise men) and magicians. People practiced Yoga" (the art of mental and physical self-discipline) and "learned their grammar and prosody." As if to say—people learned reading, writing and proper behaviour. The Indian interest in grammar is evidenced by one of the earliest known books on the subject, written by Pannini, an Indian, in the first-second centuries A.D.

Eighth century city in ancient Kashmir described.

In ancient Kashmir, people practiced Yoga and "learned their grammar and prosody".

In the most interesting and superbly illustrated book on South Indian painting by Dr. Sivaramamurti we have a chapter on *Chitrasalas* (art galleries) and, as he points out, there are numerous references in the *Ramayana,* the *Mahabharata* and various other Sanskrit texts of differing dates, that inform us concerning the buildings that contained these art galleries as well as descriptions of their contents. The famous city of the Cholas, Puhar, according to Dr. Sivaramamurti, is described in Tamil literature as resplendent with picture galleries and that its palaces were lavishly painted with murals. The same source tells us that halls with murals were like permanent art galleries, while changing exhibitions were possible when painted scrolls were unrolled and hung.

Description of Chitrasalas *(art galleries) in ancient India.*

References to paintings unrolled and hung.

For an idea of these scrolls one must look to the Patas of Nepal and the Tankas of Tibet, some still in existence, surviving from the thirteenth-fourteenth centuries, and of course the painted scrolls of China, a country with which India had contacts from early times. Sivaramamurti gives us further interesting facts about picture galleries *(Chitrasalas)*. Some were stationary, others on wheels (an early example of traveling exhibitions). Sivaramamurti lists several types of art galleries, for the palace, for the public or wealthy citizen and for the mansion of the leading courtesan. Only certain subjects were permitted in private residences including the private apartments of the king where romance is prominently portrayed, especially between sages and celestial maidens. Pictures of Kamadeva (the God of Love) had a special place in the bedroom although this god might also appear elsewhere.

Early evidence of travelling exhibitions and types of art galleries.

The famous poet Bana, during the reign of King Harsha, the emperor who managed to restore the Gupta empire in the early seventh century after it had been smashed by the White Huns, mentions snakes, celestials, demons, gnomes, dancers, harpies, lovely designs of creepers and decorative foliage. Much of this is to be seen in the Ajanta frescoes, and as hunting scenes are also mentioned in the *Navasahasankacharita,* one cannot help but conclude that the art of painting must have been continuous throughout India down through the ages to the very period of Rajput and Mughal painting. Subject matter, the love of nature, decorative foliage and creepers make one think of Bundi painting whereas hunting scenes and romances, divine or otherwise, run through both Mughal and Rajput painting, not to mention the importance of portraiture.

Bana, the seventh century poet, describes subject matter for painting reminding one of both the Mughal and Rajput schools.

Turning to the period following the Gupta age in the South, in the Talagirisvara Temple at Panamalai, a most fragmentary fresco representing a very delicate and elegant lady with a parasol is reproduced on page 39 of *Painting of India* by Douglas Barrett and Basil Gray, which they date to about 700 A.D. In spite of the charm and refinement of this painting, gone is the vigorous line of Sigiriya or the form-descriptive line of Ajanta. One also notices a lessening of the full control which artists of the Gupta age possessed in the representation of the human form at Elura where frescoes may still be seen. It may be that some of the greatest artists were already being drawn to the extremely rich kingdoms of Southeast Asia, well established by Indian merchants by the time of the Guptas.

Painting at Panamalai and Elura in the eighth century.

The upper layer of paintings in the Kailasanath Temple at Elura shows us Jain paintings datable no earlier than the eighth-ninth century with a style already exhibiting sharply drawn noses and flat eyes without sockets. This rather sharp style appears clearly related to Chola painting as seen in reproductions of Chola painting in Dr. Sivaramamurti's book, *South Indian Painting.* The style is also to be seen in Burma in the Abeyadana Temple frescoes reproduced by Gordon Luce in his book, *Old Burma—Early Pagan,*[5] leading one to conclude that artists were continuing to be brought from India to work at Pagan and perhaps elsewhere in Southeast Asia.

Jain style of flat eye socket and sharp nose already seen in the eighth-ninth century.

Chola painting seen in the Abeyadana Temple frescoes in Burma.

Contact between Burma and North India as well as the South must have existed, as B. Griswold informs us in his *The Art of Burma, Korea and Tibet,* that Kyanzittha, who ruled between 1084 and 1112, had sent a mission to Bodhgaya in India to restore the Mahabodhi Temple. It would seem unlikely that his mission did not visit all the great Buddhist centers of Nalanda and perhaps Bengal with an exchange of gifts of bronzes and paintings. Also, the Abeyadana Temple frescoes

Mission from Burma to Bodhgaya to restore the Mahabodhi Temple.

are largely tantric. Frescoes have not been recovered from either Bengal or Nalanda, so famed for magnificent monasteries, temples and libraries described at length by the Chinese travellers to India in the fourth to seventh centuries as the area was annihilated by the Muslims at the end of the twelfth century. However, some vestiges may still be discovered, and the frescoes in Burma suggest what they may have been like.

Frescoes at Nalanda may have resembled eleventh-twelfth century frescoes still to be seen in Burma.

In observing Mr. Luce's reproductions of the Abeyadana Temple walls one cannot help but notice a close similarity with the style of our three Jain reproductions in Pls. 3, 4, and 5. The same sharp little features, all drawn in a rather nervous line—the beards of the male figures also similar as are the hairdos of the female heads. Costuming and great emphasis on textile design are also comparable in each. However an even closer parallel appears in the textile designs in many of the tankas from Tibet where one will also see many figural relationships both with the above-mentioned frescoes of the eleventh-twelfth century from Burma as well as in frescoes from South India. If one looks further south to Vijayanagar, a similar sharpness and nervous quality of line is present in the frescoes belonging to the fifteenth-sixteenth centuries illustrated in Sivaramamurti's *South Indian Painting*. This will suggest the perpetuation of an Indian style of painting throughout India continuing from the Classical period.

Fifteenth-sixteenth century Jain painting compared with eleventh-twelfth century Burmese frescoes. Pls. 3, 4 and 5 mentioned.

Fifteenth century frescoes from Vijayanagar compared with Jain painting.

The frescoes of Tibet illustrated figure 72-73, Vol I in Tucci's *Tibetan Painted Scrolls,* dated in the sixteenth century, show a relationship to the dancers and drummers from the Abeyadana Temple (page 241 in *Old Burma—Early Pagan,* by G. H. Luce) which again are obviously derived from Chola India. These frescoes must have been executed by either South Indian artists or artists from Burma coming through the Assam corridor. At any rate, the similarities would imply a late perpetuation of an Indian style of painting most closely related to the Chola school. The Burma fresco style of the eleventh-twelfth century was continued up to a much later date in Java and Bali where painted cotton Buddhist stories were executed on long, wide panels of cotton in the eighteenth century.

Resemblance is seen between Tibetan sixteenth century frescoes and the frescoes from eleventh-twelfth century Burma and Chola India.

The small paintings from Nalanda possess a greater elegance and closer reflection of the true Gupta style, although even in the Pala stone sculpture a certain sharpness is evident by the twelfth century, and this same sharp style is even present in some of the illustrated book covers.

Manuscript painting from Nalanda.

In the East at Orissa, a center that produced great architecture and sculpture from earliest times, we have as yet found no remaining frescoes nor painting from anything but a relatively late period consisting of numerous narrow palm leaf pages painted with a wiry line, a line stronger and more vigorous than that of the Jain paintings which are, of course, much earlier and painted with daintier refinement. But there is evidence that this style, related to the deep South, may have been practiced for some time, as one sees in some tankas from Tibet painting of a remarkably similar character belonging to an earlier period, leading one to conclude that more than one indigenous manner of painting existed in India from Classical times.

Painting from Orissa.

An extremely fragmentary painting on cloth—India's ancient technique—has been found and is illustrated, page 72, in *Painting of India,* Douglas Barrett and Basil Gray, concerning which there may be some argument as to its precise date, but it is probably much earlier than the small palm leaf pages. It presents us with a far more realistic style of such power and brilliance that we must conclude that the artists working on the *Amir-Hamza* in Akbar's atelier were probably also drawn from this region as well as the Deccan. Four pages, painted on both sides, perhaps from a *Gita Govinda,* which Douglas Barrett and Basil Gray illustrate page 73 and describe as from Orissa, assigning them to the mid-sixteenth century, are executed with a delicate more feathery line—quite removed from the later palm leaf style. They may also be later, and already exhibit the influence introduced by the European engravings in the anatomically inspired treatment of the bodies, elongated and with very small heads. The stylized rings at the neck, however, are characteristic of Chalukyan sculpture and also of the small Jain paintings as well as the palm leaf pages of Orissa and their counterpart in Tibet.

Remarkable fragments of a painting on cloth found recently at Orissa.

Possible European as well as Mughal influence in sixteenth-seventeenth century Orissa.

Turning to the northeastern corner at Bengal and especially Nalanda, the center of great Buddhist monasteries, no traces are left but a number of palm leaf manuscripts have been recovered, dating from the Pala-Sena dynasties of the tenth-twelfth centuries, after which the area was swallowed up by the advancing Muslims. The refinement and elegance of the Gupta manner lingers longer in this northeastern corner than elsewhere in India and might be considered heir to the late Gupta style of King Harsha. It is in this area and under this dynasty that develops the form of Buddhism known as Vajrayana which will advance beyond the incorporation into Buddhism of myths and deities of Hindu origin as in Tantric Buddhism, and will concentrate on *Bhakti*. An ancient concept in India, *Bhakti* had originally been conceived of as adoration, which could be addressed to an idea without external form, but in Tantric Buddhism it will represent devotion or adoration addressed to physically perceivable objects incorporating the idea of godhood and it will now advance to the belief that the worshipper, emptying his mind of all thought, desire, and will, may, by chanting certain fixed prayers while in a state of beatitude, incorporate unto himself the spiritual virtues and attributes of the Deity so expressed by the *mantra,* (prayer) and through this process reach a state of divine enlightenment.

A religious practice then arises, popular among the masses, by which it will come to be thought that the recitation of a *mantra* by itself and of itself, by a divine act or sudden flash of insight, which this sect likened to a thunderbolt (*vajra*—also signifying a diamond, sharp with great penetrating power) might physically draw from the deity his or her spiritual attributes. Finally a popular manisfestation of the movement became popular among the masses which included the use of prayer wheels and the filling of hollow spaces reserved for the purpose in copper and brass images with quantities of stamped prayers.

This Eastern school of manuscript painting is exclusively on palm leaf. Later examples on paper are probably from Nepal as paper is not thought to have come to India before the thirteenth century,[6] although known in China from the first. Following the long and narrow format of the palm leaf manuscript, the illustration is placed in a small square in the center while the text is distributed on either side. Figures of gracefully swaying Boddhisattvas, stylized trees, small gazelles and seated female deities, often decorated with elaborate foliation, are all rendered with a fine line, the inner modeling rounding out the form in a manner recalling the Gupta period. In the rare examples with multiple figures one will observe the same Indian ability to compose in depth, suggestive of perspective, as we have noticed at Ajanta. The decorative trees and vegetation in these little paintings, along with gazelles and delicately rendered female figures, will reappear in Rajput painting, especially in the school of Bundi. At a slightly earlier period, in the fifteenth century, a much more stylized version will permeate the pages of the innumerable Jain manuscripts of Gujarat, already mentioned.

This charming late variant of the Gupta style from Bengal was carried to Nepal after the total cultural and artistic destruction of the area by the Muslims in the twelfth century. Here in Nepal a very close approximation of the style appears in the large *patas* (rolled paintings on cloth) reminiscent of the hanging paintings on cloth mentioned in the Gupta texts. Although the spiritual intensity of Gupta period Ajanta cannot be matched in these paintings from Bengal and Nepal, a gentle beatitude and absence of evil in the faces of the deities will suggest the desired spiritual grace.

The Tibetan scholar-monk Taranatha, in his writings of 1608 which appear based on strong traditional evidence, speaks of an Eastern and a Western school of painting; the Western he considers inferior to the Eastern. He is probably referring to the region of Nalanda and Bengal when he speaks of the Eastern school, as that was such a great Buddhist center from earliest times. However, the Western school to which he refers presents a problem in precise definition. Evidence shows that the late Gupta style was continued in the western Himalayas incorporating Indian, Central Asian and Chinese elements which may be seen in the frescoes of Spiti in

Palmleaf manuscripts from Bengal and Nalanda.

Tantric and Vajrayana Buddhism.

Popular manifestations with prayer wheels.

Nepalese manuscripts on paper after the fourteenth century.

Vegetation seen in early Bengal palmleaf style reappears in Rajput painting.

Early palmleaf style appears in early *patas* of Nepal.

Tarantha, the scholar-monk, writes in 1608 on the Eastern and Western schools of painting.

Ladakh and at Guge in Western Tibet. At Guge one sees floral ornament that is present in both early Nepalese *patas* and the palm leaf pages from Bengal. This Western school, practiced in Kashmir as well as Ladakh and Western Tibet, was probably carried on into a rather late period with reflections appearing in our earliest Hill Painting at Basohli in the seventeenth century. (See W. Archer, *Indian Painting from the Punjab Hills,* page 326, where he points out that certain Hill painters were known to have come from Kashmir.)

Late Gupta style in the Himalayas.

Kashmir influence in Basohli painting.

Another important candidate for the Western school of painting may be found in the large numbers of Jain manuscript pages of which we illustrate three on Pls. 3, 4 and 5 of which we have already spoken (page 5). The Jains of Gujerat, a religious sect that came into being as a reform movement more or less at the time that Gautama, the Buddha, lived, were enjoying great prosperity under Sultanate rule as they were mainly engaged in banking and commerce—activities which the Sultans favoured as a source of taxable money. Relatively free from persecution, although they would never have been allowed to erect large temples with sculptured deities, and extremely wealthy, they put their money into great numbers of richly decorated manuscripts. These they would tuck away into their *bhandaras* (libraries) of which there were many, and in which they would even include texts not pertaining to their own sects.

Jain painting as the Western school.

Pls. 3, 4 and 5 mentioned.

Jain libraries *(bhandaras).*

Although Mamluk influence is evident in the Jain pages in the Freer Gallery and the Los Angeles Museum, reproduced Pls. 1 and 2, the vast majority of these small pages, such as we reproduce Pls. 3, 4 and 5, are more closely related to the frescoes that we have already mentioned in Burma, to be seen in Gordon Luce's *Old Burma—Early Pagan* as well as to Chola frescoes reproduced in *South Indian Painting* by Sivaramamurti.

Jain painting seen derived from Chola painting with some small Mamluk influence. Pls. 1, 2, 3, 4 and 5 mentioned.

In the South at Vijayanagar, still under native rule in the mid-sixteenth century although the Deccan had been under the rule of an independent Sultanate dynasty since the mid-fourteenth century, we are told by Douglas Barrett and Basil Gray that in 1530-42 a large and impressive temple was built at Lapakshi, now a small village in Anantapur district, by two brothers from the nearby fortress of Penugonda. In a series of very fine frescoes from this temple, reproduced page 47, *Painting in India,* by Barrett and Gray, representing a boar hunt, we again see the Indian ability to compose multiple figures with animal and tree forms in depth that we saw in the Gupta age, although the illusion of distance is destroyed by a tiny figure from the background who, with bow and arrow and skirt composed of leaves, reaches his leg around the leaping boar in the foreground. Executed in a strong rather wiry line without inner modeling or much attempt at naturalistic grace in the human figures, although the animals appear to fare better, the princely hunters are bejeweled with multiple strands of pearls at neck and arms—their sarong-like wrap-around skirts minutely described with textile designs of the greatest elaboration. Behind the leaping boar and rich array of handsomely stylized trees, we see a background filled with multiple hill and rock formations in a running pattern containing animals and leaping deer in the top distance.

Sixteenth century South Indian frescoes at Lapakshi.

Compositional mastery of Ajanta still apparent.

The entire composition still exhibits the compositional mastery that one encounters at Ajanta, although explicit naturalism has been abandoned in favour of a short cut to reality, such as the far eye in heads in three-quarter view that will protrude as though seen from the front. This easy escape from the difficult foreshortening of the far eye is first seen at Elura and becomes a characteristic of the small Jain paintings from Gujerat under Sultanate rule.

The far eye protruding already seen at Elura.

On the ceiling of the fifteenth century Virupaksha Temple at Hampi, reproduced Figure 54 of *South Indian Painting* by Sivaramamurti, dating from the middle of the fifteenth century, we see a large area divided into compartments. Three center squares containing figures in action are surrounded by wide bands divided into squares and oblongs, which also contain smaller multiple scenes. All of this in turn is contained by a larger long frieze of deities and personages above, with equestrian and elephant riders at each corner, and below, a most interesting long frieze representing three long oblong compartments containing rows of

The fifteenth century frescoes from Hampi show many scenes divided into different compartments as in fourteenth-fifteenth century *patas* from Nepal and eighteenth-nineteenth century hangings from Rajputana exhibiting various interesting types of coaches or carriages.

carriages, some drawn by horses, some by elephants and some by bullocks. The coaches or carriages possess throne-like seating areas under high elaborate tiered domes, raised on columns or poles with hanging curtains, and will remind us of the curtained bullock-drawn carriages mentioned in the Gupta period texts. The driver sits up front and the entire vehicles have an imposing air of great importance. Below is a wide frieze with many marching individuals carrying banners and staffs with a lady seated in a highly ornamental litter being carried along. This type of painting with scenes divided into multiple compartments is a characteristic of the early *patas* that have been found in Nepal dating from as early as the twelfth-thirteenth centuries, and are still a characteristic of the large wall hangings from Rajputana, painted on cotton, of the eighteenth-nineteenth centuries.

That painting and probably wall painting had continued to exist all over India with varying degrees of excellence, from earliest times appears evident, but for most areas our knowledge is very limited until we come to the early Rajput and Mughal schools in the sixteenth century.

INDIA UNDER THE SULTANS

As it would seem evident that painting in India, so widespread and popular an art in the Gupta and Classical ages, could hardly have come to an end after the iconoclastic Muslim invasions took place in the tenth to twelfth centuries, it may be interesting to glimpse briefly into this period of Sultanate rule.

The first Muslim to penetrate India was Muhammad Kasim in 712, who had been appointed to the task of spreading Muhammadan power into India by his father-in-law, the great General Hajjaj, governor of Iraq.

Muhammad Kasim, the first Arab invader of Sind.

It would appear evident[7] that the first Arab conquerors were far more lenient toward the conquered Hindu population than the later Turks from Ghazni, perhaps partly because of their desert background and lack of administrative skills which would cause them to rely upon the existing patterns of government.

That portraiture was strongly in evidence in this period[8] is seen by the fact that the early invaders demanded, among other prerequisites, that the leading notables of the invading force should be presented with portraits either in stone or other media. It is also reported that when Muhammad Kasim, through treachery, was sent back to Iraq a prisoner, "the people of Hind wept for him and preserved his likeness at Kiraj . . ." It is constantly reported that India was full of artists and artisans of all sorts.

Portraiture mentioned.

Although the Arab Caliphs managed to convert to Islam all of Persia, most of western Central Asia and Afghanistan, after 300 years of increasingly tenuous rule, they were superseded by a powerful dynasty, the Ghaznavid. This family, which had been residing in Turkestan for several generations, intermarrying with the population, of Turkish descent, and converted to Islam, managed to establish a great empire which included much of central western Asia, parts of Persia and Afghanistan.

From their capital at Ghazni in Afghanistan, shortly after the year 1000, they were to stage devastating temple and idol smashing raids into the north of India, gaining for themselves great religious merit and enormous spoils in gold, precious jewels and treasure of every sort. In describing the campaign of Mahmud of Ghazni, crowned 998, in the Punjab where he managed to take the fort of Bhimnagar, also known as Nagarkot, the modern Kot Kangra, we are told of the great riches which neighbouring chiefs and devotees from different parts of India, through different generations, had deposited there. Seventy million Royal dirhams, gold and silver ingots 700,400 "mans" in weight, along with a description of precious jewels, super-fine embroidered cloths and garments as well as precious stones, all of which were exhibited at Ghazni in the courtyard of the royal palace.

Mahmud of Ghazni, crowned 998, captures Nagarkot the modern Kot Kangra.

Vast plunder exhibited at Ghazni and viewed by ambassadors from many countries.

This exhibit was visited by ambassadors from Turkestan and other foreign countries, undoubtedly serving to encourage would-be adventurers to visit the country, as well as promising vast rewards to the proselytizing plunderer.

Mahmud of Ghazni was a cultivated man, friend of poets and scholars, who filled his capital at Ghazni with great mosques and palaces and was even said to admire the magnificent architecture and sculpture which he encountered in India, remarking on the grandeur of Mathura, estimating that it could not have cost less than 100,000,000 red "dinars" which even the most skillful masons must have taken 200 years to complete. But he still did not hesitate for a minute in smashing it to pieces, the city being pillaged for twenty days, temples and most buildings reduced to ashes, the gold and silver idols confiscated—and on to Kanauj where the same story was repeated. The expedition against Kanauj is claimed to have made the sultan master of wealth amounting to 20,000 dirhams, 53,000 prisoners of war and 350 elephants, but perhaps his most devastating act of desecration was his final success in destroying Somanatha which was of all places most sacred to the Hindus. Fifty thousand Hindus sacrificed their lives to defend their deity, the great Shivalinga, which had been enshrined in the temple. The temple was razed and the Shivalinga smashed to pieces, the fragments carried to Ghazni where they were made to serve as steps at the gate of the Jami mosque.

But evidence shows that, although his iconoclastic zeal caused him to destroy heathen works which he admired, he did carry off to Ghazni artists and artisans to work on his palaces, decorating his palace walls with frescoes and possibly painting portraits as well

Fine examples of an Indianized Muslim architecture of this early period are still to be seen. Demolishing the temples of the infidel, the invaders used the building materials of the smashed temples for their mosques, and the quantities of excellent Indian architects and masons, who were among the vast numbers of slaves drawn from the conquered population, were put to work in their construction. The famous Quwwat-ul-Islam mosque, built by Muhammad's famous general Aibak in 1197, possesses an inscription which at its entrance testifies that it was built out of the materials of 27 demolished Hindu or Jain temples. The Muslims brought to India mortar, not in use in India before, which enabled the Indian architect to construct both the arch and the dome on a monumental scale, although both features already existed in India, the dome used for decorative purposes and the arch in various forms as niches for sculpture. But India is not known to have had the true arch. Indian architecture throughout the Indo-Muslim period will always have a far more plastic and sculptural character than the architecture of other Muhammedan countries.

In returning to our tale of destruction under the Muslim invaders, which is repeated over and over again from one end of the country to the other, in 1194 the general of Muhammad of Gur, the following dynasty from Afghanistan, destroyed the university city of Nalanda which he reported to be inhabited by a college of shavenheaded Brahmans. With the destruction of this great Buddhist monastery with its colleges, libraries and shrines and the murder of those monks who had failed to flee to Nepal or Burma, Buddhism was to receive its mortal blow in India.

Finally, to give an idea of the extent to which the gay pleasure-loving and cultivated society of the *Ganikas and Nagarakas* we have read about in the Gupta period quotations from Moti Chandra's book on the courtesans of India was utterly destroyed, we must turn to Ala-ud-Din, second ruler of the Khalji dynasty (1296-1316). A man of immense administrative ability as well as a great general, he had managed to unite the north of India after a period of rebellion and anarchy, even leading his armies into the Deccan. After this he had himself placed on the throne by plotting the murder of his uncle, the Shah, and in order to win the support of the various Muslim notables of the kingdom, he distributed among them largesse from the enormous spoils which he had brought back from the Deccan.

Mahmud, a cultivated man, admired what he destroyed and carried Indian artists and artisans to Ghazni to work on his palaces.

Destruction of Mathura and Kanauj with final destruction of Somanatha.

Early Indianized Muslim architecture.

Muhammad of Gur destroys Nalanda.

After a while, however, he was to face insurrection and rebellion from all sides himself, whereupon he set about to fix things so that no man would ever dare raise a finger against him again, and according to contemporary writers, Ala-ud-Din took counsel with himself and decided that several factors were responsible for disease in the body politic besides the king's ignorance of the condition of his people. He considered that drinking led to convivial gatherings, fruitful breeding grounds for conspiracies, also that intermarriage and discourse among the nobles made them a compact body dangerous to the state (they could compare notes) and finally wealth gave the people both power and leisure for evil thoughts and rebellion.

So Ala-ud-Din by a stroke of his pen, revoked all grants and pensions, resuming all lands held as proprietary rights or pensions, even pious endowments, bringing this wealth which would have been in the hands of Muslims into his treasury. State officials were instructed to extort money from the people with extreme sternness by a 50% land tax and, except for the great nobles, officers of state, wealthy merchants and bankers, no one possessed gold, with the people becoming so busy earning a livelihood that they had hardly time to think of rebellion. A second measure was a network of espionage by which the sultan kept himself informed of the doings of the nobles and all occurrences of importance in the state. Even the activities of the people in the marketplace did not escape this spy system which worked so efficiently that the nobles hardly dared speak among themselves in public.

The next important measure was a total prohibition against drinking with drastic punishments. However, in spite of the vigourous supervision of this intelligence system, it was impossible to keep Delhi dry. Whereupon the King bowed to reality, allowing private manufacture and use of drink. But both its public sale and use were totally prohibited and all convivial parties put to a stop. After this dampening effect on the cheerful society of Delhi he ordered a prohibition on all gatherings in the houses of the nobility, also placing an interdiction upon marriage between the families of the nobles without his special permission.[9]

The custom of imbibing alcohol in private before issuing forth to a public restaurant or night club was still to be observed in Calcutta in the mid-twentieth century, very possibly resulting from these repressive measures established by Ala-ud-Din.[10]

Although Ala-ud-Din's laws and regulations kept the population at large severely under heel, the vast wealth and treasure amassed at his court in Delhi was reported by contemporaries to have rivaled the splendour and luxury of Cairo and Constantinople, attracting great men from the Muslim world. But the pleasures of life appear to have been restricted to the royal court and public Darbar where the Emperor would receive in state, with the women folk of course excluded, a habit which had never prevailed in classical Indian society—Hindu, Jain or Buddhist. Under Ala-ud-Din the entertainment for the masses would include royal cavalcades when the streets would be lavishly decorated with pavilions in which were stationed beautiful singing and dancing girls.

Ala-ud-Din was successful in his campaigning in Rajputana where the important fort of Rathanbor, the famous stronghold of the Sisodiya family at Chitor was overrun in 1303, with Malwa collapsing in 1305. There is an interesting quote in the journal of Sir Thomas Roe: "Dec. 18, (1615) Five course to Cytor, an ancient cytty, ruined, on a hill, but so that it appears a toombe of woonderfull magnificence. Ther stands above 100 churches, all of carved stone, many fayre towers and lanthornes (cupolas) cutt thorowgh, many pillars and innumerable houses; but no one inhabitant."

The powerful chief of Sitwana, Sital Deval, after five or six years of bitter resistance, submitted in 1308, and Ala-ud-Din also achieved success in the south, receiving the dutiful submission (after much battling) of the king of Devagiri, but

in the end was to find himself in the midst of many troubles. Devagiri finally asserted its independence and Hammir, the ruler of the Sisodiya family, succeeded in recapturing the famed fort of Chitor. In the midst of these troubles, Ala-ud-Din passed away January 5, 1316.

Although the lives of the ordinary Muslim noblemen and of course the total Hindu population of the city, had been severely reduced to a drab existence through acute impoverishment while the court of Ala-ud-Din shone with spendour, eventually a much greater misfortune was to befall the entire city under the succeeding dynasty of the Tughluqs. While the first sultan, Ghiyas-ud-Din Tughluq, softened the lot of the Hindu to some extent with his ordinance declaring that the Hindus should neither have enough wealth to intoxicate them nor so little that destitution should cause them to leave their lands and cultivation in despair, the succeeding sultan Muhammad-ibn-Tughluq, caused the temporary removal in 1329 of the capital of Delhi to Deogiri, or Daulatabad, in the Deccan in order to be closer to his military operations in the south, and to be perhaps also closer to the nobles in his southern capital in order to prevent plots of secession. Reports tell of excessive cruelty in this forced evacuation of the city and speak of the enormous hardships the population endured on their migration south, although these same reports describe a fine highway which the Sultan had created, lined with shady trees to protect the travelers all the way to Daulatabad, as well as bounteous liberality and favours to these emigrants, both on their journey and on their arrival. However, it appears that few endured the forced march or were ever to return to their homeland.

The capital was finally restored to Delhi, but a report existed claiming that the Sultan encouraged its repopulation from other areas besides Daulatabad. The degree to which it was depopulated is disputed by modern scholars, as there is some conflict in contemporary reports as well as the fact that the city still operated a mint; nevertheless, the brilliance of Delhi as an imperial capital city must have been much reduced.

Finally, Muhammad, encountering military reversals in his extensive campaigning throughout the country, his enormous ambition having led him to desire the conquest of Transoxania and Khurasan in Central Asia, as well as confusion in the treasury resulting from his attempt to introduce a token currency, (paper money was already in use in Central Asia according to Marco Polo) and also encountering insurrection and revolt, he felt himself lost on all sides with his authority even defied by Muslim divines. It was at this point that he decided to reinforce his authority by seeking recognition from the Caliph in Egypt, and in 1340 received an envoy from the Caliphate.

This exchange of honours with the Caliph of Egypt along with his known friendship for the Jains, establishing a resthouse for their monks, would account for the presence of Mamluk influence in some surviving Sultanate as well as Jain painting in India, (see Plates 1 and 2) although it is probable that contact with Mamluk Egypt already existed, not only because of India's ancient trade with Mesopotamia but because both the Mamluks of Egypt and the Sultans of India were of Turkish descent. The Jain community, as stated elsewhere, were the merchants favoured by the sultans because of their taxable wealth, who were known to be exporters of Indian textiles to the Near East and Egypt, so manuscripts and paintings probably traveled back and forth.

Muhammad-ibn Tughluq, like so many of the Turkish sultans of India, was a man of extraordinary contradiction, perpetrating acts of almost unimagined cruelty, if contemporary reports are to be believed, yet showing a greater tolerance of his Hindu subjects than most Muslim rulers. Liberal in spirit for a Muslim, interested in supporting the Rationalists against the Traditionalists, known to be well-read, a poet himself, writing letters in both Arabic and Persian considered to be both elegant and in good taste, capable of conversing with the eminent scholars of his day and a known calligraphist, with administrative imagination and dreams of empire, he nevertheless left Delhi and the Empire in a worse condition than when he

Muhammad-ibn Tughluq removes the capitol city of Delhi to Deogiri or Daulatabad.

The capitol is restored to Delhi.

Muhammad attempts to establish a token currency.

Muhammad, in trouble on all sides, turns to the Caliphate of Egypt.

Muhammad was ahead of his time, but leaves the country in debt.

found it. He was ahead of his times—experience and knowledge of the use of a token currency did not as yet exist, bringing perhaps considerable financial troubles intensified by both the removal and the return of the imperial capital from Delhi to Daulatabad, along with the severe antagonism from his bigoted Muslim subjects who resented his tolerant attitude toward Jain and Hindu, which also alienated the Muslim religious hierarchy. His imagination and vision without his excessive cruelty will be reborn at a later date when all circumstances will be propitious for the successful establishment of one of India's greatest empires by Akbar, a truly universal man and enlightened emperor.

Firuz Shah (1351-1388), the sultan to follow Muhammad-ibn-Tughluq, although one of the wisest, most benevolent of the pre-Mughal sultans to rule in India and one who held many liberal views far in advance of his age, was again bigoted even though a great patron of learning, establishing many fine libraries and (according to the historian Firishta) even founding a fine library of Hindu books consisting of 1300 volumes.

Firuz Shah had an enormous number of slaves, some 180,000 according to reports, to whom he was extremely attached and had had them trained in all the arts and sciences. They formed his immediate entourage, of course all of them converted to the Muslim faith, and were given extreme preference which created considerable jealousy so that they fared rather badly after his death. Nevertheless, in spite of the Shah's fondness for his Hindu subjects, he could state that he labored diligently to have all things repugnant to religion set aside, which of course, meant any religious activity other than that belonging to the orthodox Muslim faith. He also reestablished the poll tax which Hindus were obliged to pay in order to practice their religion, also claiming that he destroyed all new temples erected by the idol worshipers and killed those who had them built, publicly burning their books and images before the gates of the palace.

Firuz Shah has thousands of Hindu slaves trained in all the arts and sciences.

Finally in 1398, Delhi will be completely destroyed when Timur, known to Europe as Tamerlane (the Lame), will enter North India on a conquering raid, spending three days smashing Delhi to the ground, leaving almost nothing standing beyond impregnable forts and mosques. Timur had acquiesced to the Muslim clergy with a promise to spare the lives of the Muslim population, but, as his army got out of control and proceeded to loot and plunder the possessions of the population—the population was provoked to resistance. This aroused the fury of Timur's army who put the city and its entire population to the sword and to flames—sparing none, creating a great pyramid of heads at all four corners of the city.

Timur (known to Europe as Tamerlane) levels Delhi to the ground.

The enormous wealth that had accumulated in the Imperial coffers, including untold quantities of gold and precious stones, all fell to the lot of Timur who, after a few days of massacre and destruction, moved on to other centers where much was repeated and then swiftly retreated to his kingdom in Samarkand. Delhi will return to life subsequently under the Sayyids (1414-1444) and the Lodis (1451-1526) after her utter destruction by Timur, as newer sections are built. Sir Thomas Roe in his often-quoted journal of the early seventeenth century states that "Delhi lies in utter ruins"; he means of course the old city. But it is clear that the pleasure-loving existence which one reads of in the Gupta texts had long since ceased to exist along with all the great palaces of the private citizenry which must have been on a grand scale before Ala-ud-Din Khalji reduced the population to penury.

Sir Thomas Roe writes in the early seventeenth century that "Delhi lies in utter ruins."

However, luxury and splendour undoubtedly continued to be seen in those sultanate centers that had managed to achieve considerable independence from the imperial capital of Delhi, as well as in the Hindu kingdom of Vijayanagar in the south and Orissa in the east, which had retained their independence until they finally fell to the Mughals after the middle of the sixteenth century. Rajputana in certain areas had also managed to maintain its Hindu rule, although to finally fall to the Mughal emperors.

In April, 1526, Babur will march into Delhi to establish one of the greatest empires India was to know, with a flowering of all the arts which a highly cultured

society may boast, and all this will be brought about mainly by the Hindu population itself.

PAINTING IN THE SULTANATE AGE

The degree to which painting may have existed under Sultanate rule is very much a matter of conjecture but it is known that in the time of the early caliphs of Bagdhad palaces were still decorated as in antiquity.

Dr. Ghirshman speaks of a Hellenized Parthian style of wall decoration spreading from Palmyra, Dura Europos and Hatra across Persian, and gives us examples of wall painting at Seistan in the palace of Kuh-i-Khwaja, first century A.D., illustrated nos. 55 through 58 in *Persian Art* by Dr. R. Ghirshman. The heavy, looming, rather empty figures, especially of the three gods, are aptly described by Dr. Ghirshman as ''. . . devoid of movement, indifferent to narrative and impervious to the life of forms . . .'' He speaks of a rejected Hellenizing influence.

However, both Herzfeld and Ghirshman see a return to an earlier style in the profile head, no. 58, that is also in the more earth colour palette of Mesopotamia and India, as seen at Ajanta.

There are no known Sassanian frescoes from Persia proper, but at Bishapur, in a 3rd century palace with mosaics illustrating a banqueting scene, Iranian influence is present in the seated and standing figures as well as in the costumes, although cooler lighter colours and an attempt at modeling the forms would point to a rather inept attempt to follow Rome, the source of the mosaic technique.

By the 5th-6th century at Bamiyan and Kakrak in Afghanistan, a more developed representational ability is seen, perhaps due to the presence of India where a great school of painting existed at this time. But heavy forms still persist in the large painting of a Boddhisattva at Bamiyan, which is also rather flat, but brighter in colour with much Sassanian ornamentation in flying ribbons and rounded compartments outlined with strings of pearls. The hunter king at Kakrak has also the rather round empty form, but here the colouring reverts to the earlier dark earth colours of Mesopotamia and Assyria, as well as Ajanta India.

According to Ghirshman, J. Hackin discerned two styles in the central Asian frescoes at Kizil. One, he dates to 450-650, with accurate modeling and a discrete palette, in which he says, Indian influence predominates, and in the second, dated 650-750, with brighter colours and a gradual disappearance of modeling, he sees Sassanian influence.

Another powerful influence in the painting of central Asia comes from Tang China, which introduces a rhythmic line and brilliant colour with blues and greens, although red and yellow also appear. This Chinese style is particularly adopted by the Turkish people of central Asia, and will be reflected later in the 16th-17th century Turkish tiles. It may even be seen in the 16th-17th century in the Deccan, India, where Turkish influence was strong.

It must be remembered that painting in India at the time of the first Muslim arrival was still at a high level and evidence of Indian influence is to be seen in many of the fresco paintings which have come to light in Central Asia and Afghanistan, thanks to the archaeologists. Also, fragments of Manichean paper manuscripts with painted illustrations have been found in Central Asia dating from the eighth century, which were exhibited in the Metropolitan Museum of Art (New York) in *''Along the Ancient Silk Routes''* exhibit.

One may be sure that the Ghaznavid invaders soon discovered the worth of the Indian artists and put them to work decorating their palaces but whether Indian influence was maintained into the later periods of Persian painting remains a question.

In explaining the gradual drying up of the great achievements in architecture and sculpture in India in the medieval period, the advance of the Muslim iconoclasts, who destroyed so many temples and monasteries of Hindu, Buddhist and Jain sects alike, we have answer enough, and with the end of the Vijayanagar dynasty in the South in the sixteenth century, India's great age of temple building was never to return. But painting, not requiring the enormous wealth and power needed for

Sassanian walls decorated with frescoes.

Wall painting at Samarra in 833-892.

Book seen in house of a noble of Fars in 915 with portraits of kings.

Large Sassanian painting on the rock face at Dukhtar-i-Nushirwan compared with sixth-eighth century Panjikent.

Indian influence in Central Asia.

Indian painters decorate palace walls at Ghazni.

The Muslim advance brings an end to sculpture—but painting must have continued.

the erection of large and impressive temples, would have continued on in the decoration of walls in private mansions, in the illustration of manuscripts and in paintings on canvas to be suspended on walls. But the graceful naturalism of the Gupta age would be gradually replaced by other styles, unevenly distributed over India, with the knowledge of painting retreating in some places to emerge with strength in others.

A very well documented school of painting continued to flourish under Sultanate rule in Gujarat in the West as can be seen in the great number of Jain manuscripts which have been recovered and already described in Chapter One. The wealthy Jain merchants were liberally treated because of their taxable revenue and, having great reverence for the written word (which we might find to have been the case in the rest of India had the libraries been spared by the Muslims, noting the high degree of literacy which the Gupta texts imply) commissioned enormous quantities of richly illustrated manuscripts which they hid about in their numerous libraries. See Pls. 3, 4 and 5.

Painting under the wealthy Jain merchants.

Their manuscripts are oblong in format and, after 1400, on paper, with the illustrations placed in the center with text on either side as in the palm leaf pages from Bengal, only less long and narrow. These small Jain paintings are of a hieratic and decorative order with little regard for naturalistic finesse, executed with a nervous wiry line with much regard for minutely rendered textile designs, jewelry, ornamental trees and endless bands of ornament. The bearded male heads and, above all, the textile designs will suggest the Indian-derived frescoes from Pagan, Burma, which had enjoyed a culture established by Indian merchants in the Gupta and medieval periods.

Jain painting compared with Burma frescoes.

Although it is difficult to discern Mamluk or Persian influence in the innumerable Jain manuscript pages of the fifteenth-sixteenth centuries, certain paintings executed under the sultans in Gujarat most certainly do show this influence, such as the two earlier cited pages which we illustrate from the Freer Gallery of Art, Smithsonian Institute, and the Los Angeles County Museum on Pls. 1 and 2. These are thought to be from Gujarat, and, in the bold simple design, large stylized flowers and strong colours, the Mamluk style is apparent, but the faces, especially Laila on Majnun's tomb below, show a suggestion of sixteenth century Persian painting.

Pls. 1 and 2 described.

Early painting under Muslim patronage in India has yet to make its appearance, but paintings believed not to date before the fifteenth-sixteenth centuries have been recovered, such as the rather provincial Indianized Mamluk style reproduced on our Pls. 1 and 2.

A royal Sultanate manuscript dated 1531-1532, the *Iskandar-nama* of Nusrat Shah of Bengal has recently come to light and is described in detail by Robert Skelton in *Indian Painting* of the *P. D. Colnaghi Catalogue*. The paintings in this manuscript are more truly Persian and elaborate than other Sultanate paintings we will mention, but they possess characteristics which undeniably suggest an Indian authorship, as Mr. Skelton points out. Some of the rather heavy figures to be seen on a few of the pages will remind us of Sultanate painting in the Deccan and could conceivably be interpreted as the last reflections of Sassanian or Gandharan influence. The architecture is rendered in the Persian manner, with flat areas filled with elaborate ornamentation without stressing the structural character of the building as would have been the case in most paintings by Indian artists and which we will see to be the case in the first great Mughal work, the *Amir-Hamza*. This characteristic will be discussed again later on, but it is becoming increasingly evident through the discovery of a variety of Sultanate manuscripts covering several different borrowed styles, that the art of painting was active throughout pre-Mughal Muslim rule and that these styles undoubtedly exercised some degree of influence on the formation of both Rajput and Mughal painting.

The *Iskandar-nama* of Nusrat described by R. Skelton.

The *Nimat-nama,* dated 1500-1510, in the India Office Library, illustrated in *Painting of India,* by D. Barrett and B. Gray, is a rather less interesting example,

suggesting that an Indian artist might have been inspired by a Persian manuscript painting, scattering his Indianized Persian figures against a typical Persian background of flowering shrubs spotted with flowering trees against a rather hard blue Persian style sky with Chinese clouds. The strong arbitrary design of the tent, however, suggests a relationship with a much more interesting painting illustrated page 69 of *Painting of India* by Barrett and Gray. This painting, from a *Laur Chanda* folio 149 recto in the John Rylands Library, Manchester, dated circa 1530, is too early to be in any way influenced by Mughal art, but must be thought to represent a more truly Indian character. The pointed transparent coat worn by the male figure, so often seen in painting in the *Hamza-nama* and in the early Akbar period, must be an Indian feature. One is tempted to see the skirt of this coat as descending from a square cloth with a large hole in the centre which is gathered up, the corners falling as points. The faces of both individuals resemble the faces to be seen in an early series from Chawand in Mewar, ca. 1605, an example from this series illustrated page 132 in *Painting of India* by Barrett and Gray and ascribed to the artist Nisaradi, as well as Pl. 12 in the present volume. The figures in the *Laur Chanda* manuscript in Manchester are also very Indian in character, possessing a certain sharp stiffness that will be discussed later in the chapter on Rajput painting.

Earliest Rajput style seen in the *Laur Chanda* folio 149 recto, at the John Rylands Library, Manchester.

The entire character of the Manchester *Laur Chanda* page is truly Indian. Using Indo-Persian architectural features as the backbone of the composition, the stylized structural elements will create a strong design, the building possessing a sense of depth and substance, a native Indian feature, not apparent in Persian painting, at least in the fifteenth through sixteenth centuries where architecture, however rich and elaborate, will remain flat as though existing for the sole purpose of supplying a great variety of different surfaces to be covered with every manner of ornamentation.

Indian architectural character of Manchester *Laur Chanda* page.

Another important feature in the early Sultanate page in the India Office Library lies in the way the individuals illustrating the story being told are silhouetted against flat areas of contrasting colour, always of the greatest harmony and agreeableness. In the *Laur Chanda* the colours are cool but the same style of buildings with figures silhouetted against flat colour will be characteristic of the early Mewar school mentioned above as well as in later paintings from Malwa, Mewar and Bundi, and may be traced up into the hills at Basohli as well be seen in Pls. 6 through 40 of the present volume. In these paintings the colours will usually be vibrant with strong reds, blues and greens, with brown and yellow added in wonderful colour combinations.

Figures silhouetted against flat areas of colour in the Manchester *Laur Chanda* as in early Malwa painting.

We will turn now to the natively inspired school of the Deccan under independent Sultanate rule from the fourteenth century. Here at Ahmadnagar, Bijapur and Golcanda, an individual and artistically successful school took place. In Painting at Bijapur by Douglas Barrett in *Paintings from Islamic Lands* (Vol. IV, Oriental Series, edited by S. M. Stearn, R. Walzer and R. Pinder Wilson, 1969), Mr. Barrett tells us of the evidence accumulated in recent years concerning the painting in the Islamic kingdoms of the Deccan during the sixteenth and final quarter of the seventeenth centuries at Ahmadnagar, Golconda and Bijapur. Mr. Barrett illustrates a series of folios on pages 146-56 from a manuscript of the romance of the Raja of Chitor and the princess of Ceylon now in the British Museum which he attributes to Bijapur and to a probable date in the late sixteenth century. The paintings exhibit the characteristics of the Deccani school, poetic and fanciful. Persian, Chinese and Turkish elements are already well fused and Indianized, leading one to conclude that the style developed to a certain extent independently of the Mughal school of Akbar. Persian artists may have been borrowed from the Mughal court, even in the early period before the Deccani kingdoms were completely under Mughal control, although it would appear certain that Deccani artists worked at Akbar's atelier as Deccani influence is strong in the *Hamza-nama*. It is also possible to see certain ties with Turkish painting in the Deccan as well as influence from the Portuguese colony of Goa, perhaps taking place as a result of the quantities of religious engravings coming in Portuguese ships from Antwerp in the Spanish

Painting in the Deccan.

Netherlands. The origins and development of the school of the Deccan, although also inspired by Persia, follow a quite different and independent path from the Mughal school of the north.

In *Painting of India* by Douglas Barrett and Basil Gray the complexity of the Deccani school is illustrated in a series of examples on pages 116 through 127 that show influences not only from Persia but possibly from Vijayanagar in the South, from which area artists might have sought patronage after the fall of their city. Painting from the Deccan may even reflect a remembrance of old Persian painting going back to the Sassanian tradition, such as in the large heavy forms which one sees in many of these paintings. Sassanian influence is thought to have lingered in Persia into Samanid rule (874-999) but the multiplicity of influences in this school of the Deccan would appear evident. On p. 118 of *Painting of India* by Douglas Barrett and Basil Gray we see a combination of Indian and later Persian elements. A romantic prince sits with his lady love on a bejeweled swing in a garden under trees filled with birds and heavy with richly decorative blossoms and flowering plants scattered about on the white ground. The plants, although related to Persia, have a very indigenous character and may also be seen in the *Hamza-nama*. The richly designed flowering trees owe something to the vegetation seen in the palm leaf pages of Bengal, of course Gupta inspired, and the female figures relate to many which we see in the *Hamza-nama*.

Portraiture, as popular here as it would seem to have been in the ancient past, according to the Gupta texts, differs greatly from that of the Mughal school, where in the late sixteenth and seventeenth centuries it will be carried to some of the finest achievements in small-scale painting. Here portraits are executed on a larger scale and are less concerned with incisive character penetration than will be the case in the finest examples of Mughal painting. In the example reproduced plate 127 of *Painting of India* by Douglas Barrett and Basil Gray, we see a large looming figure, Ibrahim II Adil Shah of Bijapur, his fluttering scarves and transparent skirt revealing a heavy, though soft, voluptuous form that advances with elephantine grace as he emerges from a dark mass of richly designed leafy trees, graceful plant forms under foot and a multiple turreted palace dimly seen in the upper left distance. This is one of the most movingly poetic paintings of the Deccan and will presage the lyricism of the Rajput school, now unfolding in the North.

Before leaving our brief survey of what transpired in India from ancient times to the period of the Rajput and Mughal school of the sixteenth to the nineteenth centuries, which form the subject of the present volume, let us say that fine painting may have come and gone in India as elsewhere, and remark that if one common descriptive denominator could be applied to her artistic genius throughout the ages in all media, be it architecture, sculpture or painting, it would surely be her great unfailing sense of design, the harmony of each part of the organic whole; in painting, the relation of form, line and colour to the matter in hand.

RAJPUT PAINTING
FROM THE PLAINS

The first group represented in this volume is designated at Rajput, a generic term encompassing a larger area than the geographical name implies, an area extending from the Punjab Hills through Rajasthan, Gujarat and Central India. From memories lingering in far off hill towns, from fortified castles clinging to crags that overlook the barren waste of Rajputana, a school of profound charm and poetic beauty came into being. Much crushed and reduced by circumstances after the Muslim penetration, it will look to vestiges of an ancient past to illustrate its myths and stories and will reflect many trends formerly existing in India. But it will also draw unto itself reflections of many foreign styles introduced during pre-Mughal Muslim domination, discussed in the introduction. In the less successful examples the foreign influence will dominate in styles of a certain provincial ineptitude, while in the finer examples the borrowings will blend with the native genius for poetic statement through design and colour. To this early manner, which combines a highly stylized design with evocative reflections of nature (the Indian genius could never conceive of pictorial representation devoid of human meaning) will eventually be added in the eighteenth and nineteenth centuries elements of European pictorial naturalism coming through the later Mughal style. To these many trends will be added a beguiling simplicity, seemingly of folkish character, actually of great subtle sophistication, so right will be the placement, the form and colour, in fact the entire treatment of the matter in hand. These small paintings are usually stylized and rarely attempt an exact representation, nevertheless they are most expressive of what they describe. Although the suggestions of architecture and vegetation are often extremely slight, an evocative sense of the place will be conjured up and the important moment in time established by these small formalized actors on the stage of the picture.

The Rajputs, who are considered to have entered India at the time of the White Hun invasion which brought down the Gupta empire at the end of the fifth century, are known to Indian history for their tough resistance to Muslim penetration. Their heroic tenacity might have kept them independent far longer had they had the capacity to fight in unison against the enemy, but internal squabbling caused them to fall one after the other. The most famous among Rajput defenders was the Sisodiya family of Mewar in the heartland of Rajputana, with their famous stronghold at Chitor, and their later capital at Udaipur which they built upon a lake to the West. From the thirteenth century the Muslim rulers had sent punitive expeditions from Delhi, Malwa and Gujarat against the Rajputs, but their successes were temporary. In 1303 Ala-ud-Din of Delhi stormed and crushed Chitor, (see page 10) but in less than 100 years the Sisodiyas had won it back, and, under a series of able rulers, even extended their territory. However, they were constantly feuding with their neighbours who finally, one by one, were persuaded to make terms with Akbar.

This greatest of all Mughal emperors who succeeded to the throne of Delhi in 1556, found the way to bring not only the Rajput rulers willingly within the fold of

The term Rajput includes Rajasthan, Gujarat, Central India and the Punjab Hills.

Though stylized, paintings are expressive of reality.

The Rajputs enter India at the end of the fifth century.

his empire but also to use them to advantage. In 1562, the Raja of Amber (Jaipur) was not only graciously received by Akbar, but offered his eldest daughter in marriage, the princess becoming the mother of Jahangir. As the Rajputs were men of faith Akbar acquired a sturdy ally in Amber, and Amber received through Akbar great patronage at court and a share in the spoils of war to which it was called upon to join. Bundi was persuaded to hand over the fortress of Ranthambor in 1569 and submitted on very favourable terms. In 1570 Bikaner and Jaisalmer also offered their submission, giving girls to the imperial harem. In 1581 Udai Singh of Jodhpur, one of Rajasthan's most important states after Mewar, gave his sister in marriage to Akbar and his daughter to Prince Salim who was later to become the Emperor Jahangir. Under Akbar the Rajput princes were receiving religious toleration, power and wealth beyond anything they had formerly enjoyed.

However, to all of this the Sisodiyas of Mewar remained implacably opposed, continuing their tenacious fight for independence. Ultimately, after many reverses which would oblige them to retreat to their new capital on the lake of Udaipur, or, even abandoning this, to the wild hilly fastnesses to the West inhabited by the aboriginal Bhils, in 1614 came the final collapse. Peace with Jahangir and his son Khurram, the future Shah Jahan, was established, and for Mewar, peace was to be followed by a period of prosperity and building. The city of Udaipur was surrounded by impressive forts and, from the waters of the Pichola lake rose a fairy-like structure, the Jag-Mandir.

Turning now to the painting produced in this fascinating part of the world, in this period of time, from the beginning of the sixteenth to the nineteenth centuries, we will first discuss a group of paintings considered to constitute the earliest examples of the Rajput style.

Known to many as the Kulahdar group because of a turban surrounding a cap in the center (which can actually appear elsewhere) the six examples reproduced Pls. 6 through 11 in this book are from a *Bhagavata Purana* series, considered to date to 1500-1530, and are thought to have been executed in the vicinity of Delhi or South Rajasthan. Other manuscripts of this series are dated from the beginning to the middle of the sixteenth century.

Although related to the Western school of Jain painting illustrated Pls. 3 through 5 of this book, the lively composition of the Kulahdar group as well as the absence of the extended far eye suggest the possibility of a different descent from ancient Indian traditions. A certain relationship with Basholi painting—which of course is only known from a much later period—in the bold composition, strong colouring and large eyes (although the Turkish or Kashmiri profile is missing) suggest the possible existence of an as yet unrecovered ancient school of Western painting. Perhaps this was the ancient Western school to which Taranatha, the sixteenth century Tibetan scholar, referred in his writings.

A characteristic of this series lies in the very sharp handling of all the forms which is not repeated again in quite this fashion. If we look into India's ancient past we will see that stencil cutting was one of the most popular and widely practiced arts according to the numerous references to it in the Gupta and Medieval period texts quoted in *The World of Courtesans*. Stencil cutting, possible even from leaves as the ancient texts imply, would have been an inexpensive form of entertainment for the masses in the periods of attrition under Muslim domination, and the unavoidable sharp style might have left its influence on the present series. Lush vegetation, suggestions of palace interiors and scenes of battling and romantic love also remind one of the Gupta texts which enumerate the subject matter to be practiced by painters, and for ample evidence of the wide practice of painting among the lay public in the pre-Muslim periods one must again turn to the enumerable references to it in *The World of Courtesans*.

The slight suggestions of architecture, stylized yet suggesting reality, as well as the placing of all human as well as animal forms against different areas of flat

Pl. 1 Page from a Khamsa of Amir Khusrau, Sultanate, second half of the fifteenth century, 4½" × 8¼", Freer Gallery of Art, Smithsonian, Washington, D.C. (59.3)

Pl. 2 Page from a Khamsa of Amir Khusrau, Sultanate, second half of the fifteenth century, much reduced in size. Text margins 11" × 8¼", Los Angeles County Museum of Art.

Pl. 3, 4, 5 Three pages from three different Jain Manuscripts, slightly enlarged, Private Collection. Number 3 shows us individuals riding ox carts, so often mentioned in the Gupta texts.[12]
On page 18 of *EARLY TRAVELS IN INDIA* by William Foster, C.I.E. we read that an English traveler in 1585 speaks of seeing ". . . many fine cartes, and many of them carved and gilded with gold, with two wheels, which can be drawn with two little buls about the bigness of our great dogs in England, and they will runne with any horse and carie two or three men in one of these cartes. . ."

Pl. 6 The Theft of the Parijata Tree, from a *Bhagavata Purana* series, probably Southern Rajasthan, ca. 1520. 7⅛" × 9½", Los Angeles County Museum of Art.
Pl. 7 Krishna in Battle, from a *Bhagavata Purana* series, probably Southern Rajasthan, ca. 1520. 7¼" × 9½", Private Collection.

Pl. 8 Balarama Slays a Demon, from a *Bhagavata Purana* series, probably Southern Rajasthan, ca. 1520. 7½" × 9½", Private Collection.

Pl. 9 Above—The River Flows by a Rock as Krishna Takes His Cows to Pasture. Below—Krishna and Balarama Rejoice, from a *Bhagavata Purana* series, probably Southern Rajasthan, ca. 1520. (location unknown) 7¼" × 9½".

Pl. 10 Krishna and the Cowherds Return Home probably from a *Bhagavata Purana* series, probably Southern Rajasthan, ca. 1520. 7½" × 9½". National Gallery of Canada, Ottawa. (23.584)

Pl. 11 Krishna defeats Bakasura, the Demon crane, from a *Bhagavata Purana* series, probably Southern Rajasthan, ca. 1520. 7⅛" × 9½", Los Angeles County Museum of Art.

contrasting colour is a feature which we have already mentioned as traditionally Indian when we spoke of the *Laur Chanda* in Manchester on page 15 of the chapter on Sultanate painting which is illustrated page 69 in *Painting of India* by D. Barrett and B. Gray. The architecture, especially in the examples to follow the Kulahdar group, will be highly stylized yet forming a strong design that will be suggestive of actual structures. All early painting of the so-called Rajput school, whether from the plains or from the hills, will share this feature. However removed from a naturalistic appearance, they will nevertheless convey their character and personality as buildings, capable of being moved about in, however slight the representation of the buildings may be.

The next painting which we reproduce on Pl.12 comes from a series of *Ragamala* paintings from Chawand, the last stronghold in the hills to the West of Udaipur from which second capital the Sisodiyas were obliged to flee into the hills inhabited by the aboriginal Bhils. The painting is dated 1605 and is known to be painted by the artist Nisaradi. The relationship with the *Kulahdar* group still exists in the buildings, figural types and strong designing in colour, but the clipped sharp forms have disappeared and the composition of all the early paintings from Mewar Pls. 12 through 15 will strongly resemble the Manchester *Laur Chanda* in their highly stylized treatment of the buildings that yet possess a certain actuality, as well as in the strong contrasting colours which silhouette the figures seen on these pages. These characteristics will be seen in all the early paintings from Mewar, Malwa and elsewhere in Rajputana, and will even appear in the Pahari hills in some of the most exciting paintings of the seventeenth and early eighteenth centuries from that region.

It has been suggested by some authorities that the use of brilliant red is intended by the Rajput artists to denote passion; however, as red is to be seen in compositions unconnected with romantic purpose and as other colours such as blue or green at times silhouette romance, it might be questioned whether or not the Rajput artists, deeply colour-conscious, might not use their colours for compositional effectiveness rather than as symbols of sentiment or emotion. It is clear that red would be the most dramatic colour to place behind the subject of interest, but possibly its use does not always extend beyond that. However, in referring to *Ragamala* painting, the importance of colour is obvious. Dr. Karan Singh in his foreword to *Ragamala Painting* by Klaus Ebeling points out that in *Ragamala* painting one has a blend of two separate ideas descending from both painting and music, as the Raga suggests the mood of the music as well as that of the painting. These extremely brief titles, little more than notations (a girl walking in a forest), (lovers seated on a couch), etc., are obviously designed to give full reign to the artist's creativity, just as the Sanskrit word *Raga,* meaning colour, will indicate still more the importance of colour in the composition of these paintings. In fact, it might be added that of all India's special aesthetic sensibilities, foremost is her sense of colour, its mood, its drama, and above all, its powerful effect in design. Her particular genius in the use of colour will be seen in these early Rajput paintings which seem to rely almost entirely on colour juxtaposition to give drama and character to the subject.

Returning to our early Mewar painting we have a series of three. In the example, Pl 13 dated 1650, we have a slightly more complicated composition with a group of females seated in a rigidly formalized room surmounted by a cupola while Krishna walks with the gopis under a highly decorative tree in which perches a peacock. The entire scene is placed against a brilliant red background with flat blue sky and wavy line between. An increasing naturalism, especially to be seen in the figures, will also be noted in Pl. 14 representing the milkmaids bathing. The treatment of the water, already quite different from the representation of water in Persia, is probably an Indian development. A far more elaborate treatment of water existed in Persia in the fourteenth century, brought in by the Mongols from China, at which time the representation of water and gnarled tree trunks may have entered India as well. The Pl. 15 example, from a different series, dated 1630, has a slightly more developed palace although it is still rendered in a highly

Pl. 12 Counting the Petals, from a *Ragamala* series, Chawand, Rajput, Rajasthan, Mewar dated 1605. $8^3/_8$″ × $7^3/_8$″, Los Angeles Museum of Art.

Pl. 13 Krishna Mingles with Radha and the Gopis, probably from a *Rasikapriya* series, Rajput, Rajasthan, Mewar, ca. 1650. $7^1/_4$″ × $7^1/_2$″, Los Angeles County Museum of Art.

Pl. 14 Radha and the Gopis Fetching Water, probably from a *Rasikapriya* series, Rajput, Rajasthan, Mewar, ca. 1650. $8^3/_4$″ × $7^1/_2$″, Los Angeles County Museum of Art.

Pl. 15 Krishna Bows at the Feet of Radha, probably from a *Rasikapriya* series, or a Gita Govinda, Rajput, Rajasthan, Mewar, ca. 1630. Slightly reduced. Private Collection.

decorative and stylized manner, yet suggesting perspective and reality, with figures again silhouetted against flat areas of colour.

Turning to a series from a *Rasikapriya* from Malwa, dated 1634, illustrated Pls. 16 and 17 of this volume, although buildings and landscape are simplified and stylized almost to the point of becoming mere symbols, the effect is nevertheless evocative and suggestive of meaning. This will again be a characteristic of early Rajput painting, wherever it is not weakened by a misunderstood Mughal influence, such as Pl. 147, which is an early example of Mughal influence brought into the court at Bundi. In the early Malwa example Pl. 16, we see Radha and Krishna dramatically placed against a red arch and, under flowering stylized trees, a deer gambols against the flat green wash while above a wide black band shows a storm which is pierced by a thin white wavy line representing the sky seen through the clouds. Below, Pl. 17, Krishna and Radha's lovemaking is dramatized against the red wall of the small room while a handmaiden waits outside against the cool of the green under a storm cloud upper left, ringed again by a white line of sky.

Again from early Malwa, in Pla. 18 through 21, we have four examples belonging approximately to 1640, the two examples Pls. 18 and 19 representing highly fanciful illustrations to the Ramayana painted in brilliant jewel-like colours. In Pls. 20 and 21 two deep in colour examples from a *Ragamala* show a swiftly dancing blue Krishna with high gold peacock crown headdress. In Pl. 20, with his white gauze garments flowing, he dances on a high pedestal against the dark brown and black of the night, with wildly carousing female musicians on either side, while tall cypress-like trees filled with flowering tendrils reach up into the black above. Below, the same blue Krishna sits in a red swing with Radha, surrounded by female musicians against a deep turquoise blue, while two peacocks above gather raindrops from a black storm cloud.

We turn now to a group of six more early examples from Mewar. In Pl. 22, from a *Ragamala* series datable to 1650, a lady is seated outside her stylized little palace room with decorative flowering trees, the scene silhouetted against two shades of red surmounted by a black sky. Although these compositions are small in size they have a simple largeness of composition which could be blown up into a handsome mural decoration.

Below, in Pl. 23, probably from a *Ragamala* series, again of 1650, the blue Krishna bestows a blessing on a grateful female who is accompanied by a similarly crowned companion god, the group silhouetted against a red arch with most decorative trees on each side that shoot tendrils up against the black of the night.

In the enlarged example, Pl. 24, probably from the same series as Pl. 23, colour, design and mood reach one of the most successful moments in Rajput painting. An excitement is established as the princess, attired in peacock feathers, dashes through a forest at night, again silhouetted against red, and reaches up to a frightened peacock whose head emerges from the highly decorative trees while two others walk below. Although highly formalized, the magic of a forest at night with threatening storm is felt. The examples on these pages are among the most pictorially moving of the early Rajput school.

In Pl. 25, also from Malwa and from a different series, dated 1660, we see a returned hunter silhouetted against his red room in a white walled palace, greeted by one lady as another turns in terror from the wild animals that storm the palace as an elephant walks on the roof with an uprooted tree and pelting rain finishing the scene.

The enlarged example in Pl. 27 would appear to be from the same *Ragamala* series as Pl. 25, both dating from 1660, and representing especially colourful examples of this highly decorative school, particularly on Pl. 27, where we see new elaborations of palace architecture.

Pl. 28 is an example of particularly beautiful simple colouring; seated on a red bed the lover shoots with a lotus arrow the morning cock which announces the end of the tryst. This poetic composition has much lyrical charm as has the

example on Pl. 29, probably from the same *Ragamala* series, where Krishna and Radha dance together in the rain with their small female orchestra of two while the flying geese pass above under the storm of the night.

Continuing with three more examples of this charming early Malwa school, in examples Pl. 30 and 31, we see individuals placed in small colourful rooms surmounted by architecture and night sky; then we come to one of the finest examples of this school, on Pl. 32 representing Krishna dancing in the forest at night. In flounced yellow skirts with gold crown and scarves, he performs against red between trees filled with the loveliest imaginable blossoms as well as trees with long elegant branches, gracefully swaying female musicians at his sides, with birds high in the trees against the night sky. Pls. 28 through 32 are from extremely similar sets but only Pls. 30 and 31 are certainly from the same. Note the bands of scrolliations at the bottom of each showing certain differences in style.

Paintings become increasingly rich in the rhapsodic treatment of nature, and in Pl. 33 from Mewar, ca. 1640, we see a prince draw his lady to their tryst in his bower, deeply shrouded in the rich vegetation of an Indian forest at night. It might be pertinent to state that Indian gardens have a particular magic, as their trees do not have branches lost in heavy leafy foliage as do our great protective oaks, maples, and elms. Instead, many of their trees retain the rhythmic branch structure at all times, running through great heavily hanging blossoms and beautiful leafy forms. The variety of leaf structure makes one feel that the trees have deliberately designed themselves, as though in India, nature itself participated in the desire to decorate.

In Pl. 34 a female musician stands on a stylized hill with two deer among decorative trees against the red arch of a background.

The following six examples are from Sirohi in Mewar, southern Rajasthan. The first two, Pls. 35 and 36, representing two different scenes of a princess with her handmaidens on palace terraces, already show Mughal influence in the flowering plants below, but they are still in the conceptual manner of early Mewar and Malwa painting. The colours are rich and pungent, and the early examples of this school, though much stylized, are evocative suggestions of time and place. In the following two examples, Pls. 37 and 38, we have again two different palace scenes with individuals. In Pl. 37, a prince and princess are seated on a divan against a yellow tile background covered with elaborately pointed arched niches, filled with long-necked bottles or flowering shrubs. This device of ornate niches, filled or not with long-necked bottles, is a decorative feature that runs all through Rajput painting and is even present in early Jain painting as well as our early Mewar examples, Pls. 12 and 13. On the red wall under the striped cupola where the group of ladies are sitting in Pl. 13 we see a white framed niche containing three such bottles squarely placed in the middle of the red wall with rosette compartments on each side. This is a feature native to India. One must not forget that decorative arches containing sculpture were a characteristic of classical Indian architecture.

In Pl. 40 representing a Jain master delivering a paper to his followers, the arches are used as architectural features to contain objects as well as serving as decorations, but in Pl. 39, where a lady with flowering sprays walks through a decorative park with peacocks, a red niche within a red and white striped frame is seen placed squarely in the center of the yellow sky.

Pls. 41, 42 and 43 represent three paintings from a *Ragamala* series related to similar pages in the Boston Museum of Fine Arts, probably from Mewar, late seventeenth century. They are among the finest examples of the Rajput artists' handling of nature, filled with brilliant colour combinations and a wide variety of luxuriant foliage and trees. Pl. 41 has truly the quality of a colourful and fanciful jungle, with Krishna and Radha seated in their small red house at upper left, while mountain and jungle are filled with a variety of demons, snakes, deer and a tiger, the colour dominantly in rich saffrons, browns, and reds. In Pl. 42 a prince and

princess are seated on a bed under a canopy in a luxuriant flower strewn park, while Pl. 43 again shows a princess holding flowering sprays in a beautiful flower-filled park, surrounded by deer, a pond below, a gold sky, and a prince seated at the window of a tiny palace room upper right. (This painting is reduced, as it is actually the size of Pls. 41 and 42.)

In Pl. 44, in a particularly beautiful large painting from Mewar datable to around 1720, we see multiple scenes of Radha and Krishna alternating their roles against richly detailed flowering bowers. In the top register Krishna, always blue, in full regalia with peacock headdress, triple skirt, trailing scarves and with horseshoes or clogs (see description of Pl. 48) against the gold and blue nimbus, greets Radha who stands below. In the center are three representations; in the first we see Radha in the guise of Krishna combing seated Krishna's hair, he now dressed as Radha. In the next, Krishna dressed as Radha is enthroned with Radha dressed as Krishna at her feet, while in the third, Radha dressed as Krishna kneels with Krishna dressed as Radha, and at the end of the register, Radha dressed as Krishna stands fluting while Krishna dressed as Radha admires her below. In the center and bottom registers, the roles of Krishna and Radha are again reversed.

In Pl. 45 we see a late seventeenth century painting from Mewar, pungent in saffron and brown, with touches of orange, black and grey, from a *Bhagavata Purana* series probably representing the gods and demons bringing Mount Mandara to Vishnu, while below in Pl. 46, also from Mewar but perhaps thirty or forty years later, we have stronger Mughal influence in the costumes of the hunters on horseback and on foot who dash across the rockstrewn landscape against a typical early Rajput red sky, creating a musical and poetic mood.

In Pl. 47 from a *Bhagavata* series dated 1648, we observe what Mughal influence can do to early Rajput painting, where a certain heavy prosaic literalism replaces the conceptual. This probably represents Kamsa with his demon minister.

The Bundi rajas were early to see the advantage of peace under Mughal rule, even joining the imperial armies in their last storming of Chitor. The rajas spent much of their time at the imperial Mughal court and brought back with them either some partially trained second-rate Mughal artist or paintings which their own local artists attempted to emulate.

The earliest example of painting that might be attributed to Bundi is to be seen, figures 1 and 2, in *Rajput Painting at Bundi and Kotah* by Milo Beach, the first in the Bharat Kala Bhavan, Benares, the second in the Stuart C. Welch collection, Boston. Professor Beach has established the *Ragamala* series to have been painted at Chunar for Surjan Singh shortly before 1591, at which time the Emperor Akbar, who had granted the Bundi Raja a residence in the city of Benares, presented him with the land grant of Chunar, a date at which the *Hamza-nama* was either completed or close to completion so that certain similarities seen in both Milo Beach's figures 1 and 2, and the *Hamza-nama* are easily explained.

However, along with the rather dull series seen in Pl. 47, a group of most poetic and colourful paintings will be produced at this same court at a slightly later date, to be seen on pages 144, 146 and 147 of *Painting of India,* D. Barrett and B. Gray, and in the following examples shown in eight paintings, Pls. 48 through 56.

Bundi and Kotah had originally formed one great state, but feuds in the ruling Hara clan of Chauhan Rajputs caused a separation about 1625 with the establishment of the separate state of Kotah which came to express a freer, even more imaginative school than that of Bundi, carrying the early Rajput lyricism of Malwa and Mewar through the eighteenth and nineteenth centuries, as seen on Pls. 57 through 67 of the present volume.

In Pl. 48, possibly late seventeenth century, from Mewar or Bundi, we see graceful Indian trees and in the standing figure of Krishna, a most interesting vestige of India's classical past may exist in the shoes he is wearing. We quote from page 171 of *The World of Courtesans* by Moti Chandra and read, ". . . his footwear was

Pl. 43 Princess in a Park With Deer, from a *Ragamala* series, perhaps at Mewar, ca. 1660. Approximately 14³/₄″ × 11³/₈″, Private Collection.

Pl. 44 Radha and Krishna exchanging Roles, Illustration to a Poem by Sur Das, Rajput, Rajasthan, Mewar, ca. 1720. 11¹/₈″ × 10¹/₈″. National Gallery of Canada, Ottawa. (23.586)

Pl. 45 Gods and Demons Transport Mt. Mandara and Drop It in the Sea, from a *Bhagavata Purana* series, Rajput, Rajasthan, Mewar, dated by Anand Krishnato 1700. 10″ × 13³/₄″, National Gallery of Canada, Ottawa. (23.626)

Pl. 46 A Raja Hunting, from a *Bhagavata Purana* series, Rajput, Rajasthan, Mewar, late 17th century. 9¹/₄″ × 13³/₄″, Los Angeles County Museum of Art, M. 71.1.10.

Pl. 47 Kamsa With His Demon Minister, from a *Bhagavata Purana* series, Bundi sub-school, Rajput, Rajasthan, Bundi, ca. 1648. 13³/₈″ × 8¹/₂″, Los Angeles County Museum of Art.

Pl. 48 Krishna With Two Gopis (girls faces perhaps repainted), Rajput, Southern Rajasthan, perhaps 3rd quarter of 17th century. Approximate size, Private Collection.

24

shod with horseshoes . . .'' The horseshoe is mentioned more than once in Gupta period texts and, as the picture exhibits, these will contribute a certain height to the wearer and add to his imposing appearance. Ivory shoes, also called clogs, that must be the same as these horseshoes, have occasionally been found in India. The stylized pools in the foreground of this painting resemble similar stylizations in Persian painting but the manner in which the figures, flowering bower and trees are silhouetted against deep red is most characteristically Rajput.

On Pl. 49, from Bundi, belonging to around 1700, we see a very different painting from the rather dry Mughal influenced example on Pl. 47. Here a highly emotional rendering of Indian dusk gives us a sample of the poetic quality of almost all Bundi and Kotah painting. The palace cupola rises against a deep orange sunset which fades into the blue, while the white courtyard walls are blanched in the evening light as the small seated female feeds her birds under a spreading tree already dark with the coming of night.

In Pl. 50, datable to around 1760, a mounted female warrior brandishes a sword at an armed foot soldier in a landscape exhibiting the wild romantic turbulence of the Bundi sunset sky, passionate red ground and trees all in movement, while another warrior has fallen into the mire below. In Pl. 51, painted about 30 years later, a lady is on horseback with her attendants, the horse painted red and white, a fashion to be seen also in the Kishangar schools and also associated with marriage ceremonies. Although the costumes and increasing naturalism announce an awareness of Mughal painting, the style and mood remain deeply Rajput in character in the harmonious colours of all the costumes, the lily-strewn water below and the peculiar blanching light of twilight that gives a luminous quality to both the pale sky and white wall, intensifying the slumbering dark of the lush vegetation that reaches against it.

Continuing with Bundi painting of the eighteenth century, in Pl. 52 a voluptuous Radha is seated with her handmaidens in the garden of the palace on a beautiful floral rug to the side of a complicated much ornamented palace. While in Pl. 53, from the same *Ragamala* series, a lady wanders through a highly decorative forest filled with flowers and birds, accompanied by a group of geese. In Pl. 54, probably from a different series, (as the lady musician's face exhibits greater Mughal influence) she is again in a beautiful flower and bird strewn forest of an equally stylized order surrounded by gamboling deer.

From another Bundi series of the same period, Pl. 55, a seated woman watches doves. Pungent and rich in colour, this painting is rendered in a more truly Rajput style. The harmonious colours of the costumes of the three female attendants as they stand and sit against a saffron carpet embroidered with large scrolling flowers, the drama of Radha, nude under a transparent veil, her long black hair hanging down as she sits, one knee raised, on a brilliant red couch against the black of the night, is characteristic of the dramatic colour of many paintings reaching into the hills such as at Kulu and Basohli.

On Pl. 56 the white-haired Raja, seated smoking a hookah and holding a falcon, is probably from Bundi, early to mid-eighteenth century. The delicate rather flat face with little emphasis on individuality, with textile designs in the purple brocaded pillow, brocaded green trousers seen under the white gauze overskirt and rich large flower scrolling rug of deep red underfoot, again suggests a series of highly colourful seated portraits of rulers to be found in the Pahari hills from Basohli, Kulu and elsewhere, also usually seated on highly colourful rugs, either striped or floral brocaded on deep saffron backgrounds, such as Pls. 103 and 104. After the coming to power of Aurangzeb, Mughal court patronage waned causing great numbers of artists of all ranks and degrees of excellence to find employment elsewhere, in Rajputana, Central India, the Deccan and the Hills.

Pl. 57 is a rather unusual example, probably from Kotah, mid-eighteenth century. Although much related to the highly romantic and lyrical examples shown

Pl. 49 A Lady Feeding Birds, Rajput, Rajasthan, Bundi, early 18th century. Approximate size. Private Collection.

Pl. 50 Female Warrior, from a *Ragamala* series, Rajput, Rajasthan, Bundi, ca. 1760. 13.3 × 23 centimeters, National Gallery of Canada, Ottawa. (23.593)

Pl. 51 A Princess Riding, Rajput, Rajasthan, Bundi, ca. 1790. Approximate size, Private Collection.

Pl. 52 Princess With Attendants, Rajput, Rajasthan, Bundi, late 18th century. Approximate size. Private Collection.

Pl. 53 Girl in Forest With Geese from a *Ragamala* series, Rajput, Rajasthan, Bundi, late 18th century. Approximate size. Private Collection.

Pl. 54 Girl in Forest With Deer, from a *Ragamala* series, Rajput, Rajasthan, Bundi, ca. 1790. 7″ × 10″, Virginia Museum, Richmond, Virginia. (68.8.97)

Pl. 55 A Princess Watching Pigeons, Rajput, Rajasthan, Bundi, early 19th century, $9^3/_{16}$″ × $7^7/_{16}$″, National Gallery of Canada, Ottawa. (23.592)

Pl. 56 Portrait of Megh Singh Hara, Rajput, Rajasthan, Bundi, Early 18th century. Slightly enlarged, Private Collection.

Pl. 57 Prince with Attendants Making Music in A Garden, from a *Ragamala* series, Rajput, Rajasthan, Kotah, ca. 1750. Approximate size, Private Collection.

in Pls. 61 through 67 to follow, from Kotah, here greater impressionistic freedom is seen as the musician prince, seated on his gem studded gold throne, joins in a performance with two other musicians seated below, while a third fans him with a fly whisk. Here, in the turbulent rendering of nature, all seems to toss about in lush confusion.

The enlarged example Pl. 58, from Bundi, shows Radha and Krishna depicted twice in two superimposed pavilions at left, while Radha or a princess, in a most voluptuous attitude of abandon, looks at herself in a mirror held by her handmaidens in a tropical park at right, to be dated early eighteenth century.

The examples on Pls. 59 and 60, in the Los Angeles County Museum, datable to 1720, are among the most lush examples of Bundi tropical vegetation. In Pl. 59 Radha or a princess sits with Krishna in the upper palace room while below the princess walks on her palace terrace while at right she again walks through a park. Above, in a tiny scene, a prince visits an ascetic and in an even smaller room, bottom right, a prince reclines on a couch with a girl seated behind him.

On Pl. 60, in a fanciful multiple-turreted palace, all manner of tropical vegetation is dragged about by a violent storm with two maddened elephants dashing through the scene, uprooting trees as they go.

On the following seven pages, Pls. 61 through 67, the Rajput genius in all its most playful and lyrical charm is seen. On Pl. 61 a beguiling little pearl and jewel-bedecked Radha sits on a round striped cushion trying to catch two star-like soft white blossoms falling from trees in a forest of complete enchantment. Below a turbulent sky, trees of every conceivable delight of shape and leaf-form, entwined with creepers, birds and water lilies, carry the rhapsodic love of nature to its fullest.

Pl. 62 is one of the most charming of all Rajput paintings from this same delightful series, showing Krishna the rainmaker gaily dancing with the gopis as they play their musical instruments in the forest under a stormy rain-filled sky. Frothy waters rise to the hill on which they dance and four tiny white ducks strut along the pink line of lightning.

Pls. 63 and 64 are again two delightful scenes from these garden-like forests. In Pl. 63 two small girls are seated in a tiny shrine offering lotus buds to a Siva emblem. Behind the terrace on which sits the pavilion is rich vegetation and in front, steps lead to a pool filled with birds and water lilies. A peacock, Nandi the bull and a monkey are in attendance. In Pl. 64 a gaily bedecked small female musician stands in a similar lush forest, this time filled with flowering fruit trees, a stag, deer, entwined crane, and a peacock in a tree. The scene is filled with the warmth and perfume of spring.

The enlarged example in Pl. 65 is from the same series, showing us the drama of a storm. A princess dashes to the steps of her turreted pavilion, turning to see a great peacock dash from the tree above her—the diagonals of peacock and swirling lightning above adding to the excitement of the scene.

In Pl. 66 we see a playful forest scene in which the gopis perform their tree worship rite while below Krishna, hiding behind a tiny quite transparent willow tree, watches them. Monkeys in the tree above are drawn with loving care.

In Pl. 67 Krishna dances with the milkmaids at night under the light of the moon at Brindaban. The performers are circled by a large gray mass meant as the sheen from that astral body which sits as a large gray circle in the upper right of the sky, while beyond the gray circle, the trees of the forest are clearly defined in an eerie light.

Pl. 68, a Kotah hunting scene datable to 1820, shows us one of India's most charming paintings of nature. Ladies of the harem are taking their aim at a lion and lioness from the small hunting lodge at the right, while a veritable plethora of animals and birds are strewn through a delicately lush vegetation exquisitely

Pl. 58 Radha at her toilette while Krishna waits. Rajput, Rajasthan, Kotah, 1720, 10⁹/₁₆″ × 7″, Los Angeles County Museum of Art. M.74.5.17

Pl. 59 The Month of Asadha (June-July) from a *Ragamala* series. Rajput, Rajasthan, Kotah, ca. 1720. 12¹/₂″ × 8¹/₂″, Los Angeles County Museum of Art. M.71.1.26

Pl. 60 The Month of Bhadon (August-September), from a *Baramasa* series, Rajput, Rajasthan, Kotah, ca. 1720. 12¹/₂″ × 8¹/₂″, Los Angeles County Museum of Art.

Pl. 61 Seated in the Forest, She Awaits her Lover, from a *Ragamala* series, Rajput, Rajasthan, Kotah, ca. 1740. 10¹³/₁₆″ × 7¹³/11₁₆″, National Gallery of Canada, Ottawa. (23,590)

Pl. 62 Dancing in the Rain or the Rainmaker, from a *Ragamala* series, Rajput, Rajasthan, Kotah, ca 1740. 10³/₈″ × 7³/₄″, Los Angeles County Museum of Art.

Pl. 63 Girls Worshipping in a Shrine, from a *Ragamala,* series, Rajput, Rajasthan, Kotah, ca. 1740. 10¹/₂″ × 7³/₄″, Private Collection.

Pl. 64 Princess with Deer in a Forest, from a *Ragamala* series, Rajasthan, Kotah, ca 1740. 10¹/₂″ × 7³/₄″, Private Collection.

Pl. 65 Fleeing With Terror From the Storm, from a *Ragamala* series Rajasthan, Kotah, ca. 1740. 10²/₃″ × 7³/₄″, National Gallery of Canada, Ottawa. (23,589)

Pl. 66 Krishna Watching Tree Worship, Rajput, Rajasthan, Kotah, ca 1760. 10¹/₁₆″ × 7¹/₈″, Los Angeles County Museum of Art.

Pl. 67 Krishna and the Gopis, from a *Gita Govinda* series, Rajasthan, Kotah, ca. 1750. 19¹⁰/₁₆″ × 12⁹/₁₆″. Cleveland Museum of Art, Purchase, Mr. and Mrs. William H. Marlatts Fund. (60.45)

Pl. 68 Ladies Hunting, Rajasthan, Kotah, ca. 1820. 13¹/₂″ × 10³/₁₆″, Cleveland Museum of Art Purchase, J. H. Wade fund. (55.48)

decorative to the complete rendering of every plant, rush and tree. A Persian inspired white crag appears tossed in the right distance, capped by a small shrine against a red sunset sky. Naturalistic and in detail with every water lily or rock drawn in highly decorative detail, the general effect conveys an emotional sense of the wildness of nature, although of a rather fairyland order. Kotah hunting scenes interpret the wild craggy landscape of Rajputana as no other painting could.

The drawing on Pl. 69 is of a lion hunt from Jodhpur, or possibly Kishangarh, as great exaggeration appears in the lifted arch of the eye. In this exciting scene with hunters on horseback pursuing boars, two on foot attacked by lions, the entire background is composed of a beautiful floral scrolliation of much elegance. This type of scrolling ornament is to be seen in much Mughal palace decoration and also on large metal surfaces.

On Pl. 70, possibly from the Deccan and late eighteenth century, a romantic scene is shown of two warriors on horseback with their dogs who pass through a yellowish landscape which, in spite of a river or pond filled with water lilies in the middle distance and a few small trees, seems both vast and remote. This sense of lonely space is perhaps due to the receding lines of distant hills, the few trees that diminish in size into the distance and the far off character of the barren crags of the horizon. The suggested perspective of the landscape is perhaps more Deccani inspired than Mughal, but the once-upon-a-time mood of the painting is especially Rajput.

In Pl. 71, a Prince and Princess float in a water lily and is probably from Kishangarh, early eighteenth century. A suggestion of Mughal court painting hovers in the distance, although the sentiment and the rather stiff simplicity of the formal tree edged pool in which the prince and princess float is very Rajput in character. Above the formal row of trees, geese fly in the misty sky, and below all kinds of birds and fish toss about among the water lilies. The faces of two handmaidens are tucked behind two trees as they watch the floating pair.

Pl. 72 is probably late seventeenth century, and probably from Central India. The peculiar feather-like treatment of the rock formations appears in Deccani painting as well as Rajput and undoubtedly descends from early Arab painting. The delicate female musician in an animal-filled landscape with gamboling deer also suggests the Deccan. Mughal influence is absent, but the rather impressionistic sky might suggest a later date.

Pl. 73 shows us a much later and more stylized rendition of a similar *Ragamala* scene as Pl. 72. Although probably also from Central India, it bears some resemblance to Deccan painting in the almost pointed green hill that rises to a small white and pink shrine at the top, while trees and a wide pink road wind up to it. The female musician, now elegantly elongated, stands leaning against the tree with gamboling deer at her feet. The red sky, however, is a Rajput feature.

We now turn to a group of paintings executed in the small principality of Kishangarh established around 1609 by Kishan Singh, the eighth son of Raja Udai Singh of Jodhpur. Bounded by the princely states of Jodhpur and Jaipur, as well as being crossed by the Aravalli hills, the state takes its name from Kishan Singh. Although the founder had been to the Mughal court of Akbar, paintings from this small state are practically unknown before the eighteenth century when a late Mughal style appears, as in the two paintings of horses with grooms, Pls. 74 and 75, but the fame of this state lies in the paintings of a slightly later date and will extend into the nineteenth century where a series of highly emotional and romantic paintings takes place, deeply imbued with the concept of ''Bhakti'' mainly manifested through devotion to Krishna. This style, which seems to vibrate with ecstatic fervour, is characterized by highly stylized human faces with enormous eyes ending in great fishtails. The facial type is so characteristic of this school that it may almost be compared with the stamp which the Egyptian ruler Akhenaton placed on Egyptian art of the New Kingdom. The example Pl. 77 shows us a seated princess, or perhaps Radha, with gold-fringed halo kneeling and turning to reveal the typical Kishangarh profile.

Pl. 69 Hunters in Arabesques, drawing, Rajasthan, Jodhpur, ca. 1840. $14^5/_8$" \times $9^7/_8$", Los Angeles County Museum of Art.

Pl. 70 Two Horsemen, probably from the Deccan, late 18th century, $8^1/_2$" \times $6^1/_6$", Los Angeles County Museum of Art.

Pl. 71 Prince and Princess Floating on a Lotus, Rajasthan, Kishangarh, ca. 1710. $9^3/_8$" \times $6^3/_8$", National Gallery of Canada, Ottawa. (23,616)

Pl. 72 Girl With Deer, from a *Ragamala* series, Rajput, perhaps Central India, late 17th century. Private Collection.

Pl. 73 Girl With Deer, from a *Ragamala* series, probably central Rajasthan, ca 1750. $9^1/_2$" \times $6^1/_4$", Los Angeles County Museum of Art. (M.71.1.42)

Pl. 74 Horse and Groom, Rajasthan, Kishangarh, ca. mid-18th century. Approximate size, Private Collection.

Pl. 75 Horse With Two Grooms, Rajasthan, Kishangarh, ca. mid-18th Century, Approximate size, Private Collection.

In the small painting Pl. 76, in a palace at night, a prince draws a nude but bejeweled princess covered only by a transparent gold-beaten scarf (a finely woven material known to Indians as "spun-air" since antiquity) to his white and gold couch on the palace terrace. This is a typical example of the passionate and sensuous love of romance seen in Kishangarh painting, datable to 1780, and is in the Los Angeles County Museum.

The large example, Pl. 78, is also painted at Kishangarh although it represents the Maharaja Pratap Singh of Jaipur (1778-1803) and is more Mughal in style. Dressed in a diaphanous gold-brocaded muslim coat wearing multiple strands of pearls alternating with emeralds and rubies, a hawk on his gloved hand, he sits on a red and white decorated steed, two large rubies at the horse's neck. They pass through a vast green landscape with an immense sky above which tapers from orange to watery blue. Hilltops in the distance reveal a minute scene with a red fort in the center and armies marching through trees on either side while, silhouetted against the orange sky and in the green of the lower distance, tiny figures are dotted about with an extensive white palace in the distant right. The painting conveys a sense of vastness—typical of the Indian landscape—where distance is always lost in dust or smog and never is there the blue of the Italian sky where all may seem cut out and placed against it.

In the example on Pl. 79 of the mid-eighteenth century, a Raja in green with pink brocaded saddle, brandishing a sword, is seated on a rearing pale gold mount that is being attacked by a wounded and bleeding tiger.

In Pl. 80 a Raja with a more typically Kishangarh physiognomy, dressed in a scarlet costume, sits as a warrior on a large grey stallion whose lower portions have been painted red and bordered by tiny plants with a great emerald attached to a chain at his neck. The background appears to be a scrub-filled desert. This painting probably belongs to the end of the eighteenth century.

The two unusually large formal portraits from Marwar, on Pls. 81 and 82 of about 1720, are remarkable examples of the Rajput sense of design. Although the features of each are extremely similar, each manages to convey a different personality, the individual at left appearing younger than the one at the right. The examples on these two pages as well as the following four, Pls. 83 through 86, demonstrate the fact that fine Rajput artists could still handle colour most effectively in the late period.

This is especially to be seen in the portrait Pl. 83 from Bundi to be dated as late as 1830. The elderly gentleman in white, leaning against a great white bolster and seated on a flowering rug, smoking a hookah, seems well set off by the deep brown, red and white stripes below and the intense blue sky above that silhouette his subtly painted face.

Going back to the beginning of the eighteenth century and from an unknown area of Rajasthan, Pl. 84 is a highly conceptualized version of the ladies of the harem at the hunting lodge. Standing outside, the figure of a princess turns to rebuke the hunter who has just shot a great black and white buck that is catapulted into the air while two deer rise to him from below. Continuing with Pl. 85, in a portrait of a black-bearded individual in tall red turban and saffron coat, we have one of the most striking and decorative paintings in the book, from Marwar of the mid-eighteenth century. We end the Rajput series with a dashing and humorous representation of a naughty elephant running off with two terrified Mahuts on Pl. 86 from Koteh, early nineteenth century, placed against a saffron background, the painting is stunning both in its drawing as well as in its colours.

Pl. 76 Love Scene, Rajasthan, Kishangarh, ca. 1780. 7¹³/₁₆" x 5", Los Angeles County Museum of Art.

Pl. 77 Radha, Rajasthan, Kishangarh, ca. mid-19th century. 7¾" x 6½", National Gallery of Canada, Ottawa. (23.596)

Pl. 78 Raja on Horseback, Rajasthan, Kishangarh, ca. late 18th century, slightly reduced, Private Collection.

Pl. 79 Tiger Attacking a Raja's Horse. Rajasthan, Kishangarh, ca. late 18th century. 9¹³/₁₆" × 7⁵/₁₆", Los Angeles County Museum of Art. (M.71.1.28)

Pl. 80 Krishna as Warrior, Rajasthan, Kishangarh, late 18th century. 10⁷/₈" × 9¹/₄", Los Angeles County Museum of Art. (L.69.24.320)

Pl. 81 Large Portrait Bust of an Individual in White Floral Coat, from Jaipur, Rajasthan, ca. early 18th century. New York, Private Collection.

Pl. 82 Large Portrait Bust of an Individual in Pink & Black Striped Coat, 17¹/₄" × 12¹/₈", National Gallery of Canada, Ottawa. (23.597)

Pl. 83 An Elderly Raja, Rajasthan, Bundi, ca. 1830. 13⁵/₈" × 12¹/₈", National Gallery of Canada, Ottawa. (23.634)

Pl. 84 A Princess Turns at the Shooting of a Buck, Rajasthan, ca. early 18th century. 7⁷/₈" × 5⁵/₁₆", National Gallery of Canada, Ottawa. (23.604)

Pl. 85 Portrait of a Raja, Rajasthan, Marwar, ca. mid-18th century. 12¹/₂" × 8⁵/₈", Los Angeles County Museum of Art.

Pl. 86 Bhim Singh's Rampaging Elephant, by Mohammad (?), Rajasthan, Kotah area, ca. 19th century. Slightly reduced, Private Collection.

Pl. 1

Pl. 2

Pl. 3

Pl. 4

Pl. 5

Pl. 6

Pl. 7

32

Pl. 8

Pl. 9

Pl. 10

Pl. 11

Pl. 12

Pl. 13

एककासरे मसजीसजीमील जाउडमनाकीपानी अयोदोरीसजीकुंछलकरी
लीश्रगागरी झांकांनी हं ज्ञानु कौईदीषपाहुनी हु हसीउरलपहानी लागी
नाखीमनत्रीउ मग्पी फारीहुडीलललचानी

Pl 14

एककसमे श्रीकसन श्रावनराक्षजीरपगलागारतेरीसीमाणीराधजीकसनसीकदेलेमुरा
हरथीजाऊ केसवजाऊ माधवजाऊ मोसूकुउेबादमतबसेर उघणीऋसनीनोमाटीकुरबे
ीतोथेतीहीराजजाऊे थारेऔषेपीकलागेनेमुषेकजललागोछानीपीवनबलागानोतुव्ह
नमतपतीत्रतारीसोल्ही नोउजारजाह॥

Pl. 15

36

Pl. 16

Pl. 17

Pl. 18

Pl. 19

Pl. 20

Pl. 21

39

Pl. 22

Pl. 23

40

Pl. 24

41

Pl. 25

Pl. 26

Pl. 27

Pl. 28

Pl. 29

Pl. 30

Pl. 31

Pl. 32

Pl. 33

Pl. 34

Pl. 36

Pl. 35

Pl. 37

Pl. 38

Pl. 39

Pl. 40

51

Pl. 41

Pl. 45

Pl. 46

Pl. 44

Pl. 43

Pl. 42

Pl. 47

57

Pl. 48

Pl. 49

Pl. 50

Pl. 51

Pl. 52

Pl. 53

62

Pl. 54

Pl. 55

मेघसीघजीहोड़े

Pl. 56

Pl. 57

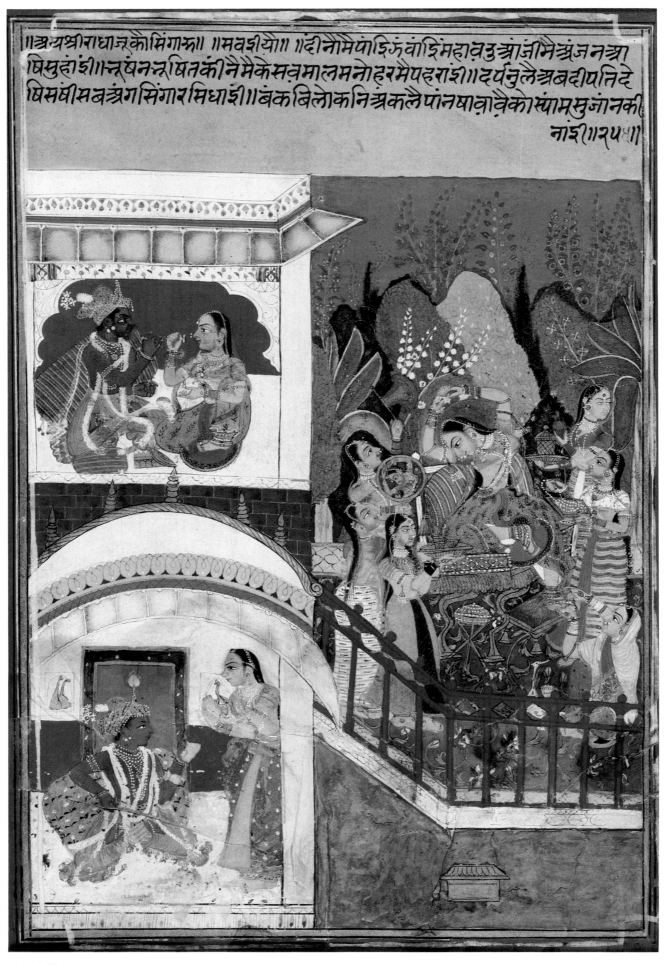

॥त्र्यश्रीराधाज्ञेकोसिंगाऊ॥ ॥सवश्चीयो॥ ॥दीनौमेपोइ इंस्वांदि महावठुत्र्याजीमिन्चंजनत्रा
षिसुहांशी।ाच्चषेनत्रृषितकीनैमैकैसव्वमालमनोहरमेपहराशी।ादर्पनुलेश्वबदीपतिदे
षिसखीसव्वत्रैगसिंगारसिधाईं॥बंककिलोकनित्रकलैपांनषावावैकोसांमसुजांनकी
नाईं॥र५॥

66

Pl. 59

Pl. 60

Pl. 61

Pl. 62

Pl. 63

Pl. 64

Pl. 65

Pl. 66

पाशिक...यनु तट...पर ...न वेदाशीचकरणज

Pl. 67

73

Pl. 68

74

Pl. 69

Pl. 70

Pl. 71

Pl. 72

Pl. 73

Pl. 74

Pl. 75

81

Pl. 77

Pl. 76

82

Pl. 78

Pl. 79

Pl. 80

Pl. 81

86

Pl. 82

Pl. 83

Pl. 84

Pl. 85

श्रीद्वारबीमसीगजीकोंद्याती

द्यातीनागीसंमसेर

कारीगरमोमट्टाकाहातकी

Pl. 86

coming rains. On Pl. 128 Siva greets Parvati on a hillside, the baby elephant god riding the white bull Nandi along the tree-lined hill above, while a monkey at right carries a tiger tied up with an axe and in Pl. 129 Siva is playing the drum for the terrifying goddess Kali, the pointed hilly landscape filled with replicas of Kali and human bones.

Pl. 130 is from either Hindur or Kangra, ca. 1820. In a stormy forest of much delicate charm, with flowering tendrils above among the trees and water lilies and small cranes in the pond below, we see two groups of Radha and Krishna exchanging roles. At left, standing on a coiled serpent under a great umbrella the blue Krishna stands with Radha. And at right, seated together on a pedestal of large petal-like leaves, Radha is blue and Krishna is white.

Pl. 131, from Guler and datable to 1780, presents us with a group of delicately painted ladies attending a princess who sits on a low silver throne or bed smoking a Hookah in her palace garden, with white buildings on each side, and beyond is spread a beautiful view of a lake with distant rolling hills.

On Pl. 132 Siva and his small goddess stand beside the great while bull Nandi by a lake under a flowering tree which sends out dainty flower-dotted streamers that wind about the tree trunk. Although the painting belongs to ca. 1800 and is in the Mughal-inspired style, the foliage of the tree returns to the petal-like design of the earlier period. The entire painting is imbued with the spirit of spring.

On Pl. 133 belonging to a Kangra kalam or provincial Hill school of the early eighteenth century, we have perhaps one of the most luscious and sensuous paintings of spring. As a young girl bathes in a lotus-filled pool in what seems a tangled mass of flowering trees and tendrils, we feel engulfed in the hot, heavily scented late spring air.

In Pl. 134 in a slightly provincial manner of the late nineteenth century, a princess with two female attendants sits on a palace terrace watching a storm. The painting has much charm and mood although the figures of the delicate ladies are rather stunted.

On Pl. 135 we see a late painting from Garhwal of ca. 1840. Siva and Parvati sit under a tree against a deep tomato red background with their large bull Nandi, Siva's emblem of power and masculinity, with their two sons, Ganesh, the elephant-headed, and Karttikeya (or Skandha), the god of war. The rat below is Ganesh's companion which signifies the fact that sheer force cannot always succeed alone, as a rat can penetrate by stealth; therefore together they are omnipotent.

The example of Pl. 136 shows a Raja embracing his Rani on a bed supported on green feet and covered with a white sheet which is placed over a running stream in a garden. They are surrounded by a red tent, with a flowering canopy above. The Raja is smoking from a hookah, as two female musicians perform lower left and a nurse, who has fallen asleep, attends the pair by the bed. This rather sensuous scene is under strong Sikh influence, early nineteenth century.

Pls. 137 and 138 show two extremely charming Kangra drawings. In Pl. 137 Krishna combs Radha's hair as they sit under a tree in a most delicately drawn landscape with cows and trees in the background, while in figure 138 a lady is seen writing a letter.

Two charming drawings bring our Rajput collection to a close and we will now speak of the Mughal school.

Pl. 128 Shiva with Parvati, Skanda, Ganesh and Hanuman, Punjab Hills, perhaps at Siba, ca. 1820. Approximate size, Private Collection.
Pl. 129 Siva with Kali, Punjab Hills, ca. 1820. Approximate size, Private Collection.

Pl. 130 Radha and Krishna Exchanging Identities, Punjab Hills, perhaps at Kangra, ca. 1820. Reduced by ½, Private Collection.

Pl. 131 Lady Smoking a Hookah, Punjab Hills at Guler, ca. 1780. Reduced by ½, Private Collection.

Pl. 132 Siva and Parvat with Bull Nandi, Punjab Hills, ca. 1800. Approximate size, Private Collection.

Pl. 133 Girls Bathing, Kangra kalam, ca. 1800. Approximate size, New York City, Private Collection.

Pl. 134 Ladies on a Palace Terrace, Kangra kalam. ca. 1830. 7" x 8³/₈", Private Collection.

Pl. 135 Siva and Parvati With Bull Nandi Enthroned, Punjab Hills, mid-19th century slightly reduced, Private Collection.

Pl. 136 Raja With A Rani, Sikh Influence, early 19th century. Reduced by ½, Private Collection.

Pl. 137 Krishna and Radha (drawing), Punjab Hills, ca. 1800. Approximate size, Private Collection.
Pl. 138 Woman Writing, (drawing), Punjab Hills, ca. 1800. Approximate size, Private Collection.

with river. Garhwal has produced some of the most beautiful hilly landscapes with trees, as one sees in Archer's book pages 75-80. Pl. 118 shows a very large painting, perhaps from Kangra, nineteenth century, representing Radha and Krishna seated facing each other on a white terrace against an olive night with black storm clouds above and a gold line of lightning. The example on Pl. 119, probably from Guler or Kangra and datable to 1810-1820, is a particularly lovely painting of a lady in pale lavender running from her terrace to the door of her pavilion against a black stormy night.

It is in comparing the large painting on Pl. 118 representing Krishna and Radha with the lady in lavender Pl. 119 that one may observe the difference between a painting by a fine artist and one which is a copy, perhaps of a copy. The painting of the lady fleeing the storm is particularly subtle and rich. The linear details of the white architecture both of the building and terrace blend into the general tonality as does her lavender garment, also the dark grayish greens and reds of the doorway of her palace blend into the dark of the interior, as does the black of the night with the different grays of the curling storm clouds, whereas in the painting in Pl. 118 each area is painted with a lack of regard for the tonality of the others and the low parapet of the terrace appears lined by a ruler on a perfectly flat piece of paper.

On Pl. 120, possibly from Mandi, datable to around 1810-1820, is seen an adoration of Siva by various gods with Parvati praying at his knee in a turbulent landscape of precipitous rock, trees growing at great angles filled with flowering streamers with animals and gods perched about, while Siva and Parvati appear to float on a tiger's skin in a forest at the top. The painting is fresh and spontaneous without the hard stiffness of a copy.

Pl. 121 is a beautiful painting which represents homage to Siva, Parvati and Skanda, painted around 1800 from Guler. With strong Mughal influence, the painting possesses refinement and delicacy in its draftsmanship. The page has been slightly cut.

Pl. 122, probably from a *Ramayana* series and perhaps unfinished, represents the departure of the demon troops across a wide palace courtyard, disappearing out the arched gate of the white wall while a many-armed king sits with his animal guard at the window. From either Guler or Kangra, late eighteenth century, this painting is a fine example of the poetic handling of the approach of night in Hill painting. The figures against the brown of the courtyard are muted, while the white walls of palace and courtyard gate have the blanched tone of dusk against the darkness of trees that rise beyond.

Pl. 123 from Garhwal, late eighteenth century, is one of the most lyrical and spontaneous examples from the Hills. In an enchanted landscape of flowering trees, river with swimming cows and a minutely painted hilltop castle that appears to float in the sky in the center, Krishna flutes and Radha gathers sprays.

On Pl. 124, probably from Chamba, ca. 1810, a fluting Krishna stands with Radha under a great white umbrella in the rain, peacock at right, beautiful flowering trees at left, village in the background and great storm clouds above from which pours down the rain.

Pl. 125 is a most delicate and charming example of ladies on a palace terrace from Kangra. Here a princess is seated against a red bolster on a low silver throne listening to a message which her kneeling handmaiden delivers while another stands behind her with a fly whisk, the white wall of the palace set off by the brilliant red of a tent wall at left. The pastel shades of the garments blend into a harmonious colour scheme. Although examples of this nature are copied in great numbers, they lack the tonality and freedom of execution of this example.

On Pls. 126 through 129 we see four examples from Mandi datable to 1820. In Pl. 126 ladies are folding their saris in a landscape while one holds onto a palm tree, and in Pl. 127, a prince and princess stand in a stormy landscape awaiting the

Pl. 110 gives us fine late seventeenth century Mughal draftsmanship from Guler, as we see wildly carousing villagers dance to music supplied by four musicians at right. Drawn and painted with great character and action, the deep scarlet background reveals a Punjab origin. Archer has dated this example to 1740 in his book, *Paintings from the Punjab Hills*.

Pl. 111, much reduced in size, shows two seated ladies playing a game while one smokes a hookah, with saffron and green hills behind. Here the poetic and delicate draftsmanship is characteristic of all of the loveliest paintings of the mid-eighteenth to nineteenth century from Garhwal, Kangra, Nurpur and a number of other places. This example in the Los Angeles County Museum is stated to be from Nurpur, by an artist named Jaimal and described as mid-eighteenth century.

In Pl. 112, we now see the full emergence of the Kangra palace landscape; in this case in a series of palace units. In the left center in a palace courtyard, a princess stands looking into a mirror held by one of her handmaidens while at the right ladies converse in an open-to-view palace room with a similar open room to the left. In the center, over a pink wall, we see turreted and colonnaded buildings with more ladies standing at a large square doorway, while above, great black stylized storm clouds roll up. Mughal influence is very clear but the naturalism of late eighteenth century Mughal painting, which at the various late Mughal courts in India has lost much of its character, has here been transformed into quite a new statement. The loveliness of nature is very much felt, but all is stated with emphasis on the formal and conceptual; the various building units, in different shades of pink and gray against dark rolling storm clouds, the pleasing tonality of the delicate ladies' garments, create the charm typical of the late Hill style generally known as Kangra painting.

Pl. 113 from Dalatpur, datable to around 1780 is an interesting composition with a river running diagonally through the center of the painting, probably representing the diverting of the river Jamuna. Krishna plays the flute surrounded by cowherds and brown and white cows and at the right the Gopis dance, some falling to the ground with the white palace dimly seen upper right and small white houses spread through the middle distance. Here the palette returns to the deep rich earth tones of an earlier period although it was probably executed towards the end of the eighteenth century.

On Pl.114 we have one of the loveliest of the late eighteenth century paintings in the Kangra style from either Kangra or Guler, representing a seated princess (or Radha) in yellow skirt looking into a mirror held by her handmaiden in a blue skirt, in a palace courtyard under a tree while three handmaidens screen her by holding a white sheet, although Krishna (or a prince) is peering at her toilette from an upper window. In all fine paintings in the Kangra style (intending by "kangra" all late painting from the hills) the draftsmanship is refined and subtle—note the delicacy with which Radha's black locks are treated as they curl in strands at her neck and waist.

On Pl. 115, a lady in transparent pale yellow coat over red pants, a finger to her lips as she leans against a tree with daintily dotted floral streamers, a large leafy pedestal under her feet, turns to the moonlit opening that lights up a distant village as the sliver of a moon rises above scrolling dark storm clouds. She stands in a moment arrested in time—a heroine of the romantic night.

Pl. 116 is a night scene of a rather different order, probably belonging to the early nineteenth century and under strong Sikh influence. Here a lady in red speaks to the shadowy form of the demon of the tree surrounded by snakes, a peacock, a deer, a running man and a small seated snake charmer at left. According to Goetz, the ancient religion of the Himalayan region was strongly imbued with snake and demon worship

In Pl. 117, from Garhwal and probably to be dated around 1790, from a *Markandeya Purana* series, two sages are seated in a beautiful tree-filled landscape

Pl. 110 Dancing Villagers, Rajput, Punjab Hills, perhaps at Guler, ca. 1740. $9^7/_8$″ × $14^3/_{16}$″, Los Angeles County Museum of Art.

Pl. 111 Ladies Playing a Game, by Jaimal, Punjab Hills, perhaps at Nurpur, 1760. $10^1/_4$″ x $7^5/_8$″, Los Angeles County Museum of Art.

Pl. 112 Preparation for a Tryst, Punjab Hills, ca. 1790. Approximate size. Private Collection.

Pl. 113 Krishna Fluting, from Dalatpur, ca. 1780. Approximate size, Private Collection.

Pl. 114 Lady Looking in a Mirror, Punjab Hills, Kangra School, ca. 1800. 23.2 x 16.5 cm. Cleveland Museum of Art, Purchase, Edward L. Whittemore Fund. (53.245)

Pl. 115 Lady Awaiting Her Lover, Punjab Hills, Kangra School, ca. 1800. 24 x 14.8 cm., Cleveland Museum of Art, Purchase, Edward L. Whittemore Fund. (32.118)

Pl. 116 The Lady and Tree Ghost, Punjab Hills, early 19th century, $10^1/_8$″ x $7^5/_8$″. National Gallery of Canada, Ottawa. (23.630)

Pl. 117 Sages in a Landscape, from a *Markandeya Purana* series, Punjab Hills, perhaps at Garhwal, ca. 1785. Approximate size, Private Collection.

certainly the same individual as our portrait of Rajah Dalip Singh. Although Archer's portrait is starkly simple ours is in a most romantic setting with beautiful Mughal trees with twisted trunks that finally become a characteristic of Kangra painting.

Pls. 98, 99 and 100 are from a *Ramayana* series. Pl. 98 represents the small figures of Lakshman and Rama, armed with bow and arrow, accosted by a great demoness with the highly decorative trees which we have just encountered from Kulu. The painting has a scarlet background, a strip of blue for sky and the faces are again in the early Hill style. It is probably from Kulu and datable to 1700, but the two examples seen in Pls. 99 and 100, although also from a *Ramayana*, are in this writer's opinion either from a different series, copied at a later date, or by a different artist, as the drawing of the trees and monkeys as well as the general tonality has undergone a very considerable change, resulting in dryer, less harmonious colour and a coarser more perfunctory draftsmanship.

On Pl. 101 a Raja with tiny floral dotted coat, black beard and red turban, is seated against a deep pink and a pale green bolster smoking from a glass hookah. He is probably from Mankot and datable to c. 1690, as his Turk-Afghan physiognomy is characteristic of early Hill painting. The line of his coat has great style and flair; the draftsmanship is careful and polished, even to the reclining hand, and the drawing of the figure has a degree of rhythmic stylization which is missing in the example on Pl. 102 from Billaspur which has been placed here to show the contrast in the more truly naturalistic late seventeenth-early eighteenth century Mughal approach to portraiture, although both portraits are probably of about the same date. According to W. B. Archer, Dipchand in 1650-1667 campaigned for the Mughal emperor Aurangzeb and his experience at the Mughal court might well explain the arrival of a few Mughal painters at Bilaspur in the seventeenth century.

The example on Pl. 103 is one of the most strikingly handsome colour schemes of the book, representing the stylized portrait of two young princes seated on a turquoise, black and pink rug silhouetted against a saffron ground with flowering plants and cypress trees. It is from Mankot, c. 1700-1710. Here they sit staring into space with a sense of the timeless.

On Pl. 104, also from Mankot and datable to 1700, is seen one of the most stunning Hill paintings of the book. A Raja in white, with two girls on his knee, is seated on a red divan with green bolster, a striped rug of dark blue, green, and white below with a red-lined canopy above. The entire scene is silhouetted against a saffron ground as in Pl. 103, and it can truly be said that the colour schemes of these two examples could hardly be more pleasing.

The four examples on Pls. 105 through 108, are from Bilaspur, two examples of which are reproduced in Archer's *Painting from the Punjab Hills* page 172, and dated around 1680-90. This superb series is already well infused with late seventeenth century Mughal influence to be seen especially in the costumes. The handling of subject matter is still conceptual, as in Pl. 105 where a prince in pink coat and striped pants, standing against a dark hill with night sky, holds gigantic lotuses that grow from a pond below. The ladies with the bull Nandi, Pl. 106, is a decorative composition as is the Prince being greeted, 107, and again the prince drinking in 108. The architecture in 107 carries on the very early Hill style seen at Kulu and Basohli.

Pl. 109 is from Chamba and may be dated 1760-65. A most dramatic painting, it already announces the Kangra style to come showing Radha and Krishna waving at parting in a forest of schematically arranged trees blackly silhouetted against an eerie saffron light with a dark band of blue above and dark ground underfoot. The red border intensifies the deep colouring and mood of the painting. Again, one senses the timeless mood of "once upon a time."

Pl. 98 Rama and Lakshman With a Demoness, from a *Ramayana* series, Punjab Hills, perhaps at Kulu, ca. 1700-10. Approximately 7″ x 12″. Private Collection.

Pl. 99 Jambhavat and the Monkeys in Council, from a *Ramayana* series Punjab Hills perhaps at Kulu, ca. 1700-10. 7″ x 12″. Private Collection.

Pl. 100 Rama's Armies storming a Mountain cave, from a *Ramayana* series, Punjab Hills, perhaps at Kulu, ca. 1700-1710. 7″ x 12″. Los Angeles County Museum of Art.

Pl. 101 Seated Ruler, Punjab Hills possibly Mankot, ca. 1690. 7½″ x 7½″. Los Angeles County Museum of Art.

Pl. 102 Portrait of a Raja, Punjab Hills, from Bilaspur, ca. 1670-1700. Approximate size, Private Collection.

Pl. 103 Two Courtiers, Punjab Hills, from Mankot, ca. 1700. Approximate size, Private Collection.

Pl. 104 A Seated Raja With Two Girls on His Knees, from the Punjab Hills at Mankot, ca. 1700. Slightly enlarged, Private Collection.

Pl. 105 A Prince with Lotuses, from a *Ragamala* series, Punjab Hills, at Bilaspur, ca. early 18th century, 10¼″ x 7¾″. Los Angeles County Museum of Art. M.71.1.49

Pl. 106 Two Ladies with a Bull, from a *Ragamala* series, Punjab Hills, perhaps at Bilaspur, ca. early 18th century. 8¼″ × 5⅞″. Los Angeles County Museum of Art. L.69.24.304

Pl. 107 A Prince Returning, from a *Ragamala* series, Punjab Hills, at Bilaspur, ca. early 18th century, 10⅛″ x 7¾″. Private Collection.

Pl. 108 A Prince Drinking, from a *Ragamala* series, Punjab Hills, at Bilaspur, ca. early 18th century. 10⅛″ x 7¾″. Los Angeles County Museum of Art. M.71.1.29

Pl. 109 Radha and Krishna in a Grove, Punjab Hills, at Chamba, ca. 1760. 8⅜″ × 11½″. Los Angeles County Museum of Art.

extremely rich and harmonious colour scheme. A princess in dark coat thinly striped with gold, wearing orange striped pants sits against a great bolster of harmonizing olive and dark gray, her handmaiden's black skirt decorated with a red ruffle, while both figures are set off by a saffron bordered olive rug with the luminous white wall of the palace room topped by a turreted roof. All is placed against a dark chocolate night.

In Pl. 95 the princess and her handmaiden are again seated in a white room, this time with pink striped rug and pink bolster behind the princess who wears a rich blue and gold striped coat, with again a similar roof. At left, a prince, already dressed in Mughal costume, in pink coat, pink turban, dark blue and gold brocaded sash, pink striped trousers, red shoes and with a white and gold decorated scarf, approaches the little house silhouetted against a deep saffron ground with tiny trees upper left. Both Pls. 93 and 95 are bordered with deep red into which the turrets of the buildings penetrate, a device often present in Persian painting where the subject will spread to the outer page. Although the early style of the Hills is strongly imbued with a local Hindu personality of a highly sophisticated nature, some influence from painting under the Sultans must have been felt, but the Hill Paintings that we are familiar with, most of them post-dating the seventeenth century and even the eighteenth and nineteenth, are of course Mughal-inspired, which influence is again of a widely complicated character with a strong sub-stratum of Indian tradition and feeling.

Pl. 95 The Lover Arrives, from a *Rasamanjari* series, Punjab Hills, prehaps at Nurpur, ca. 1710. 6½ " x 10½ ", Private Collection.

Although the *Rasamanjari* series from Nurpur, Pls. 93 and 95 is stiffer and more formalized than the great early examples on the five preceding pages, as well as some of the fine masterpieces to come, the colour harmonies in all of this set are of an order hard to surpass. Pinks, saffron and orange, strong blues and olive-grays, black, chocolate and red, are handled with a subtle dexterity that is not present in the copies and in later schools, which will be particularly noticeable for their breakdown in general tonality. In these later copies, each colour will be used individually and separately without regard for its neighbours, resulting in a rather dry effect.

Pl. 94, representing Krishna with sword and black shield, seated on a white palace terrace against a deep red sky with three highly stylized Pala or Nepalese derived trees, while his groom in green approaches with a blue horse, is from an unidentified area of the Punjab Hills, most probably Kulu. With rich colour tonality and less stylized than in the Nurpur series, it was probably painted around 1720.

Pl. 94 Described here.

On Pl. 96, a princess nude but for a diaphanous white scarf, is seated on a low ornamented throne with gilt carved legs, one knee up and the other foot on matching foot-stool. Although painted in the rich earth tones of early Hill painting, with the early Basohli and Kulu type physiognomy, a suggestion of air and space is already present in the dark saffron background that rises to a strip of blue sky above. The delicate treatment of hair and gauze garments, already naturalistic, announce the Mughal presence in the Hills in the early eighteenth century.

Pl. 96 A Seated Princess, Punjab Hills, from Basohli, ca. 1710. 8½ " x 5⅝ ", Los Angeles County Museum of Art. M.79.9.11

This leads us to one of the most poetically beautiful portraits in the book, on Pl. 97 in the Cleveland Museum of Art, perhaps from Bilaspur in the Punjab Hills and belonging either to the late seventeenth or early eighteenth centuries. It is almost certainly by an artist from some Mughal center who has become totally imbued with the deep tonality of early Hill Painting, as well as already capturing the poetic and romantic mood that will be a characteristic of the finest of the later painting from Guler and Kangra, which styles will finally engulf the entire Hills. A prince in yellow coat, scarlet turban and sash, sits holding a letter on a pink floral terrace against the cool olive dusk, birds and willow tree high in the sky while the darkness of night envelops the twisted trees at each side. A portrait of Rajah Dalip Singh (1695-1741) of Guler illustrated no. 31 page 294, from Archer's *Indian Painting from the Punjab Hills,* which he considers to have been painted at Mankot, is almost

Pl. 97 Rajah Dalip Singh of Guler with book, 1700. 22.8 x 15.6 cm, Cleveland Museum of Art, Purchase, Mr. and Mrs. William Marlatt Fund, 60.49.

Bengal and Tibet, as well as Ladakh and Kashmir, are clearly suggested. Interestingly enough the earliest Hill style is also related to the earliest paintings from Mewar and Malwa, represented in our book, Pls. 12 to 40, and the scholar-monk Taranatha, writing in 1608, links what he speaks of as the ancient Western school of painting to Rajasthan and Kashmir.

On Pl. 87, in one of the most beautiful early Basohli masterpieces, an imposing white Siva with his small worshipping Devi on his knee, both with highly formalized Kashmir-derived facial type, sit on the elephant demon's hide, floating in silvery clouds with small decorative trees (obviously Pala manuscript derived) below. Flying cranes and duck-filled pond complete the scene, relating the poetic character of this painting to the Rajput plains at Bundi in Rajputana. The cool blues and pinks of the colour scheme, more Chinese in character, are to be seen in pages 47 and 85 of Madanjeet Singh's *Himalayan Art*. For a fine description of this painting see Stella Kramrisch's *Manifestations of Siva,* exhibit of 1981.

The two examples Pls. 88 and 89 are in the much warmer earth colour palette of Ajanta and early Nepal. Pl. 88 is a rather unusual specimen and might even come from the seventeenth century Deccan. The elongated female figures, standing slightly off-balance, are also to be seen in the Deccan, which had been under independent Sultanate rule up to the reign of Aurangzeb. The faces also lack the early Himalayan character but the pungent colouring does suggest early Hill painting. It is never to be ruled out that artists could have travelled back and forth great distances or that paintings could be brought from afar, exercising considerable influence.

Pl. 89, probably from Basohli and datable to 1670-75, with four female dancers at left under a roofed pavilion with the throned god Siva at right worshipped by Vishnu and Brahma in a small palace room, is a very typical example of the early Hill style, especially in facial type and pungent saffron colouring. The same compositional device seen in early Rajput painting, especially at Mewar and Malwa, where simple architectural features are used almost exclusively for the purpose of design, becomes slightly more ornate and less functional in the early Hill paintings, which characteristic will undergo a complete change with the arrival of Mughal influence at which time a far more naturalistic treatment of buildings, landscape and human figures will take place. Here again, as in Rajputana, beautiful colour schemes are established by the juxtaposition of different forms and shapes against flat areas of colour.

The large example seen in Pl. 90, Siva with his goddess Parvati seated on a lion skin with pink crags at right, peered at by a great peacock perched on a decorative tree, buck and doe below, all placed against a saffron background, is a fine example of early Hill painting probably from Kulu. The subtle and harmonious tonality as well as the style of the drawing, which has both refinement and delicacy, is a characteristic of early Hill painting which tends to break down in later examples.

Pls. 91 and 92 are among the finest Hill Paintings known, from the famous Shangri *Ramayana* series from Kulu, dated by W. B. Archer in his *Indian Painting from the Punjab Hills* to 1675-1700. Decorative and conceptual, beautifully composed with ornamental trees and buildings, the colour harmony in this series ranks among the finest in Hill painting, but costumes and some of the faces already suggest the Mughal presence.

Pls. 93 and 95 show us two paintings from a *Rasamanjari* series from Nurpur, seven examples from which are illustrated in W. B. Archer, *Indian Painting from the Punjab Hills,* page 307-310, and dated 1710. Although slightly more contrived and stiff than our earlier Kulu and Basohli paintings just described, the compositions with architecture are now more structural and less purely ornate, appearing closer in style to our early group from Mewar and Malwa, with again silhouetted figures placed against contrasting colour. The example in Pl. 93 is an

Pl. 87 Shiva and Parvati Enthroned, Punjab Hills, Basohli, ca. 1690. 9$^{1}/_{8}$" × 6$^{1}/_{4}$", The Cleveland Museum of Art. Purchase, Edward L. Whittemore Fund. (52.587)

Pl. 88 Princess With a Falcon and Attendants, Punjab Hills, ca. 1670-1675. 8$^{1}/_{4}$" × 11$^{7}/_{8}$", Los Angeles County Museum of Art.

Pl. 89 Shiva Worshipped by Brahman and Vishnu, Punjab Hills, ca. 1690. 7$^{3}/_{8}$" × 11$^{1}/_{4}$", Los Angeles County Museum of Art. (M.81.8.11)

Pl. 90 Shiva and Parvati Enthroned, Punjab Hills, ca. 1700. Approximate size, Private Collection.

Pl. 91 Rama, Sita and Lakshman With Villagers, from a *Ramayana* series, Punjab Hills, perhaps at Kulu, ca. 1690-1700. 8$^{3}/_{4}$" × 12$^{1}/_{2}$", Los Angeles County Museum of Art. (M.77.19.22)

Pl. 92 Rama Greeted by Priests, from a *Ramayana* series, so-called 'Shangri' series, Punjab Hills, perhaps at Kulu, ca. 1690-1700, 8$^{3}/_{4}$" × 12$^{1}/_{2}$", Los Angeles County Museum of Art.

Pl. 93 Ladies Conversing, from a *Rasamanjari* series, Punjab Hills, perhaps at Nurpur, ca. 1710. 6$^{1}/_{2}$" x 10$^{1}/_{2}$", Private Collection.

Pl. 94 Krishna Inspecting a Horse, Punjab Hills, ca. 1700. Slightly reduced, Private Collection.

by Madanjeet Sing, Snellgrove considers later, but prior to the fourteenth century. Here the style has become even closer to early Hill painting, which may represent a remnant of a great tradition.

The four specimens of fresco painting which we have mentioned from Alchi alternate between the cool pinks and blues of Chinese Central Asia and the more pungent earth colours of Ajanta, as do our early Hill paintings, the first example being mainly in tones of silvery-blue. But the majority of the Hill paintings will tend to a more saffron and orange tonality with rich browns and greens, such as the three examples reproduced on Pls. 88, 89, and 90. *Both cool and warm colours seen in Alchi frescoes.*

Pls. 88, 89 and 90 discussed.

The frescoes which we see at Alchi are in a highly sophisticated style, as are our early examples of Hill painting reproduced in the present volume. As time progresses, sophistication diminishes until a totally new style is introduced by Mughal influence in the eighteenth century through the arrival of fine artists from the imperial Mughal centers, where patronage had declined.

The Hill states were being reshuffled at the time the paintings now known as the Hill Painting School came into being. It is interesting to observe that the early paintings from almost every region are in the Kashmir-influenced style above mentioned, but as time passes into the eighteenth century late Mughal painting comes to the hills, particularly to Kangra, finally engulfing the whole region. But this late Mughal school, often rather soft and sentimental, is in no way to be equated with what it inspires in the hills, as the strong tradition of conceptual design will reinterpret the rather tired and soft Mughal naturalism into a fresh new poetic statement. A lyrical love of nature is combined with tender and romantic lovers, usually Krishna and Radha. They wander or sit in landscapes of rolling hills, beautiful trees with well articulated branches and trunks, or moonlit night scenes of absolute enchantment. These are repeated over and over again. Palace and court-yard scenes, often incorporating people and landscape as well, are of a particular loveliness. *Kashmir influence in early Hill painting.*

That a tradition of painting existed in antiquity in the Hill states is also made more probable by the fact that, as W. B. Archer points out in his *Indian Painting in the Punjab Hills,* a highly developed and sophisticated art of music was found at the Hill courts when they were first discovered by the British and European travelers at the beginning of the nineteenth century. As Mr. Archer informs us, some of the singers and dancers were resident at one court, while others traveled from place to place, thus reminding us of tales of Indian dancers and musicians traveling through the courts of Central Asia in the Gupta period. This reinforces the argument that painters also travelled from court to court as their fame brought them commissions, lesser artisans remaining behind to make endless copies from their work. *Probability that painters travelled from court to court.*

The vast majority of paintings from the hills are most probably the work of lesser artisans who endlessly copied the works of fine visiting artists at the different courts. There is every evidence that artists of great talent were much in demand everywhere, and as they travelled about a stylistic diffusion would take place. The following series of paintings from the Hill states will not always be presented in an exact time sequence, as it is the purpose of this book to make an effort to present a stylistic development and progression, only possible where a very substantial number of large clear colour plates of high aesthetic quality are present to illustrate this thesis. *Majority of Hill paintings are probably copies made from the work of fine travelling artists.*

We are told by Archer that, with the exception of Rajas Bhupat Pal (1573-1635) and his son Sangram Pal (1628-73), both of whom attended the Mughal court ca. 1613-35 and 1640-41 respectively, the Mughals had little influence on Basohli life and after 1650 no Basohli forces were involved in imperial campaigns. This would account for the strong traditional Himalayan character of Basohli painting. The Mughal presence is hardly suggested in Basohli painting in the early period, whereas traces of stylistic elements of a far earlier period, the late Gupta style of Nepal,

RAJPUT PAINTING
FROM THE HILLS

In turning to painting from the hills at Basohli, Chamba, Jammu, Bilaspur, Kulu, Mankot, Nurpur and elsewhere, the earliest known style, dating only from the seventeenth century, is related to the style of the earliest Rajput painting. Here, as in Rajputana, the design is created by strong simple architectural details in combination with highly stylized figures placed against different flat areas of colour; but the earliest paintings in the hills will treat the architecture in a slightly flatter fashion with much ornamentation, perhaps closer to Muslim influence while the individual portraits will differ greatly in their physiognomy, apparently reflecting the ancient influence of Kashmir. The facial type, with the line of the receding forehead flowing into a long prominent nose and with very large eyes, is not only to be seen in early Kashmiri bronzes of the eighth-eleventh centuries but also in many stone sculptures of the Gupta and slightly later periods as well. This characteristic may be accounted for by the entrance into the Himalayan region of India by Central Asian tribes in the wake of the White Hun invasions of the sixth century. The entrance to India from Afghanistan was through this area which was constantly penetrated by Turkish peoples coming from Central Asia. Chinese pottery figurines representing Central Asians with long Turkish noses remind one of so many portraits from this Western area. Hill paintings have not been found that could be considered earlier than the mid to late seventeenth century and W. B. Archer in his great work, *Indian Painting in the Punjab Hills,* London, 1973, tells us that it is as if the school of Punjab painting developed out of nowhere. However, Randhawa, in discussing the Shangri Ramayana series, which paintings are among the most sophisticated and beautiful of the early hill style, two examples from which are reproduced, Pls. 91 and 92 of our book, tells us in his *Basohli Painting,* 1955, that they were painted in Kulu in the reign of Rajas Jagat Singh and Bidhi Singh (1637-1672 and 1672-1687) and that he had been told they were painted by a family of Kashmiri Brahmins whose descendents still lived in Paljhot, a village near Naggar, the summer capital of Raja Jagat Singh. Therefore, we may have here a family of traditional Kashmiri painters. Considering the very unsettled character of the Hill states in the early Sultanate period, often invaded, their buildings, usually of wood as are the temples of Chamba described by Hermann Goetz in the *Early Temples of Chamba,* 1955, would have been burnt to the ground and any paintings, either on walls or palm leaf, totally destroyed.

But if one turns to a group of well preserved mural paintings at Alchi in Ladakh one sees a style of great sophistication and elegance with Kashmir-derived physiognomies, receding forehead flowing into a long Turkish nose, small mouth and chin with very large eyes, that will suggest the existence of a great school of painting in the Himalyas, very Kashmir related, which may be ancestor to the early Hill painting of Basohli and Kulu. This style incorporates Central Asian, Chinese, Persian and Kashmiri elements.

David L. Snellgrove and Tadeusz Skorupaki, in *The Cultural Heritage of Ladakh* date the Du-khang and the Sum-tsek Temple to the eleventh-twelfth century, but the painting on the standing Boddhisatva in the Sum-tsek Temple, plate X in Snellgrove, which is also illustrated Pl. 85 in a large detail in *Himalayan Art*

Earliest Hill style related to earliest Rajput style.

Facial type of early Hill painting Kashmiri derived.

Saka invaders of India in 6th century bring Turkish facial type.

Families of Kashmiri painters reported in 1637-1687 and Pls. 91 and 92 discussed.

Origin of Basohli style seen at Alchi-Ladakh.

Pl. 87

103

Pl. 88

Pl. 89

Pl. 91

Pl. 92

107

Pl. 93

Pl. 94

Pl. 95

Pl. 96

Pl. 97

Pl. 98

Pl. 99

Pl. 100

113

Pl. 101

Pl. 102

Pl. 103

Pl. 104

Pl. 105

Pl. 106

118

Pl. 107

Pl. 108

Pl. 109

Pl. 110

Pl. 111

Pl. 112

Pl. 118

Pl. 117

Pl. 116

Pl. 114

Pl. 113

Pl. 119

Pl. 120

Pl. 121

Pl. 122

Pl. 123

Pl. 124

Pl. 125

Pl. 126

Pl. 127

136

Pl. 128

Pl. 129

Pl. 130

Pl. 131

138

Pl. 132

Pl. 133

Pl. 134

Pl. 135

Pl. 136

142

Pl. 137

Pl. 138

143

MUGHAL PAINTING

The Mughal empire of India is considered to have commenced with the triumphal march into Delhi by Babur, April 27, 1526.

Babur was not enthusiastic over what he found, or so goes the report in his memoirs, but one must realize that much of Delhi lay in total ruin due to Timur and that April is one of the hottest months of the year in North India. Nevertheless, as Stuart C. Welch tells us in *The Grand Mogul* by Milo Beach, hardly 100 years will pass before Shah-Jahan, Babur's fourth descent grandson, will cause to be inscribed on his palace walls, "If there be paradise on earth, it is here, it is here, it is here."

Babur, fifth in descent from Timur, the Turkish conqueror known to Europe as Tamerlane, as well as through his mother from Chingiz Khan—the Mongol of whose ancestry he was less proud—had inherited a small kingdom in Central Asia including Ferghana of the famous horses and Samarkand. But after losing them both to the great Uzbek conqueror, Shaybani, with the assistance of Shah Ismail, turned his attention to the conquest of India, first establishing himself at Kabul in Afghanistan. Although between 1512 and 1526 several unsuccessful attempts were made into the Indus Valley, complete success will result from the Battle of Panipat.

Babur, ruled 1526-1530.

Babur conquers India at the Battle of Panipat 1526.

Although Delhi more or less retained the time renowned status of imperial city, other great imperial centres existed as well, and right after the Battle of Panipat, Babur's eldest son Humayun was sent to seize the former Sultan Ibrahim's household and treasure at Agra, while he himself descended upon Delhi.

However, after making himself master, he was to find his troubles far from over, spending his time warring with insurgent Afghans as well as toughly resisting Rajputs and this constant battling will continue on into the reign of his son Humayun who will come to the throne in 1530.

Battling continues into the reign of Humayun (1530-1556).

Humayun's reign was not distinguished by military brilliance, nor was he noted for his dashing personality. In fact Babur, in his memoirs, implies that he was a bit of a religious prig, stating that "much rain was falling; parties were frequent; even Humayun was present at them and, abhorrent though it was to him, sinned (i.e., drank alcohol) every few days . . .". Several years will be spent campaigning unsuccessfully until he is forced out of India by an Afghan of true genius from Bihar who first drives him from the Gangetic plain, then from Delhi and finally from the Punjab plains in 1543, proclaiming himself Sher Shah Sur.

Humayun was also to find himself unable to gain control of Kabul in Afghanistan as it was held by his younger brother, Mirza Kamran, as Turkish custom divided the inheritance among all the sons. Therefore he was obliged to turn, in 1543, to Shah Tahmasp of Persia, the successor of Shah Isamail, for assistance in recovering his Indian kingdom.

This is an event of the greatest significance for the future of painting in India, for it is during his stay at the Persian court that Humayun will acquire a deep interest in painting. The aging Shah, now interested in religion, allowed him to carry one of his finest painters, Mir-Sayyid Ali of Tabriz, on his return to Afghanistan. Towards his return Shah Tahmasp had given limited assistance after exacting a promise from him that he would convert his kingdom to the Shia sect, although the Mughals belonged to the Sunni (two Muslim sects already in conflict at this time), as well as to restore to Persia Qandahar (Afghanistan's strongest fort). Neither of these two promises was kept, Humayun claiming that Persian assistance was not as promised.

A most important event had taken place during Humayun's incessant battling to retain his Indian kingdom, when he met and married the daughter of his brother Hindal's spiritual tutor, a native of Khurasan, named Manida Banu, who gave birth to a son in 1542, who was to become one of India's greatest emperors, the famous Akbar who is regarded as the founder of the Mughal empire in India. While Humayun was campaigning to recover his Indian kingdom, Akbar was left in the care of his uncles at Kabul in Afghanistan.

Akbar is born in 1542, as Humayun battles to regain India.

After capturing Qandahar in 1544 and dislodging his younger brother Mirza Kamran's hold on Kabul, Humayun is known to have established a great workshop in this latter city under the guidance of the fine painters which he managed to draw to him from Shah Tahmasp's court.

After the death of Sher Shah and his follower, Islam Shah, the collapse of the Sur dynasty left North India in a weakened state which enabled Humayun to reenter Delhi on July 23, 1555, bringing along with him his workshop of painters, although no examples can be attributed with certainty to either Kabul or the workshop of Humayun in India. But after so many arduous battles for the reestablishment of his Indian empire, two years later, Humayun was to meet his end coming down his library stairs in too much of a hurry for his evening prayers, leaving his son, Akbar, to bring forth one of the finest moments in Indian history.

Humayun establishes workshop of painters at Kabul.

Humayun re-enters India, bringing his workshop of painters, but dies within a year, falling downstairs on his way to prayer.

Although a military genius, Akbar was a universal man of great tolerance and wisdom but his interest to the art world will remain his dedication to the art of painting.

Akbar, the greatest Mughal Emperor 1556-1605.

The kingdom which young Akbar had inherited was far from stable, composed of various Afghan factions and Rajput princes in revolt. Humayun had left his son in charge of an exceedingly able general and administrator, Bayram Khan but by 1560 the fine old general was removed through palace intrigue instigated in the harem principally by one of Akbar's former wet nurses, Maham Anka, who had managed to establish great power and influence, all of which she used in favour of her son. Finally, her son so overstepped himself that he dared to keep to himself the booty of Mandu after the conquest of Malwa, which came to the attention of Akbar who promptly had him hand it back, after which he had the temerity to murder the husband of another of Akbar's wet nurses, Ataga Khan, one of Akbar's ministers. This act caused Akbar to throw him to his death over a balustrade and also caused young Akbar to break completely with all the restraining influences of the palace, and, taking all the reins of government and the army into his own hands, shortly showed a strength and determination which began to move all in front of him.

Akbar faces a turbulent kingdom and much palace intrigue.

Akbar asserts himself as a great leader.

The first part of Akbar's rule was to be spent warring with the Rajputs whom he finally succeeded in bringing into the fold of empire, as much through fine diplomacy as successful military exploits, and after extending his empire to Vijayanagar in the South and Orissa in the East, Akbar was to undergo a complete change of heart, looking upon all warfare as a thing of evil, deeply regretting the enormous numbers of lives that had been lost. Having already created one of the greatest empires India was ever to know, he turned his mind to acts of beneficence and peaceful pursuits, along with painting and the natural sciences.

Akbar extends his empire South and East, then turns to thoughts of peace.

Akbar's active and enquiring mind led him to a deep interest in the religions and philosophies of all people whose exponents were constantly to be found at his court. One must not forget that Vasco da Gama managed to make the Cape of Good Hope, anchoring off the coast of Malabar in 1498, and, when landing at Calicut and asked what he came for, as Michael Edwards informs us in his *History of India,* his reply was, "Christians and spices." The Portuguese conquered Goa in 1510 and, with a string of forts, brought conflict to Gujarat, killing its ruler, Bahadur Shah, when he was on board a Portuguese vessel negotiating a treaty at Diu, a small island in Portuguese possession off Gujarat, in 1537. As it is clear that the Portuguese purpose in India was directed as much to the making of Christian converts as it was to the establishment of trade, their tool for the former would have been the Bible, and most probably, religious pictures as well. It is known that Christian priests from the colony of Goa were at Akbar's court in the late sixteenth century, and that copper engravings of Christian subjects in the late European mannerist style, brought from Antwerp in the Spanish Netherlands in Portuguese ships, were already making their appearance towards the end of the sixteenth century at the Mughal court. This will be mentioned later in discussing the different European influences to be seen in early Mughal painting.

Akbar's interest in philosophy leads him to an interest in all religions.

So much has been written of the character and personality of this great man that we will limit ourselves to a few remarks made by his contemporaries. On page 278 of William Foster's *Early Travels to India* we have a quote from one of the early travelers, Thomas Coryat, who relates and interesting story about Akbar and his mother to whom Akbar was most devoted. Akbar's mother had requested Akbar to hang a Bible about the neck of an ass and let it be beaten around the town as the Portuguese had hung a Koran about the neck of a dog and beaten it around the town of Ormuz. "But Akbar denied her request saying that if it were ill in the Portuguese to doe so to the Alcoran (Koran) being it became not a king to requite ill with ill, for that the contempt of any religion was the contempt of God, . . ."

European painting already brought to India in the sixteenth century by Portuguese apostolizers.

Character of Akbar.

We have another interesting quote from the Commentary of Father Monserrate, the Portuguese priest at Akbar's court, stating that "The emperor is not a Muhammadan but is doubtful as to all forms of faith and holds firmly that there is no divinely accredited form of faith because he finds in all something to offend his reason and intelligence." To Father Monserrate this was the voice of an evil agnostic; however, such an attitude could have saved the world from a sea of blood not only in the Orient but in Spain, Europe and America. This is not to say that Akbar was not deeply superstitious but it is to say that he did not take his superstitions all that seriously.

Also in the journal of Father Monserrate we learn that when a large region experienced drought and famine it was excused the year's tax levy. This is not the action of an ungenerous ruler and might be compared favourably with the attitude of the landowners in Ireland during the famous potato famine.

However, there is no doubt that Akbar, capable of noble and magnanimous actions, was also guilty of extraordinary acts of cruelty true to his Turkish ancestors, but his contribution to his age in the realm of all civilized activity including science, comparative religion, philosophy, history and above all painting, gathered to his court great men from all fields of endeavour and he had enormous numbers of books prepared in his atelier on all subjects in spite of his illiteracy.

Extreme contradiction in character of Akbar.

There is evidence that young Akbar was given drawing lessons at Kabul by the Persian artists his father brought from Shah Tahmasp's court in Persia, but this was perhaps when he was older and not long before he was to return with his father to New Delhi so that it is possible that in those years when learning is easiest, the incessant battling and campaigning of his father, as well as the feuding among his father's brothers with whom young Akbar had to be left when his father was obliged to seek assistance from Shah Tahmasp in Persia, prevented young Akbar from receiving enough tutoring and attention. But as Emperor he was responsible for the establishment of many schools. Akbar's interest in painting descends from the later period in Kabul.

As has often been pointed out, few men in history have been singly responsible for a great cultural age—but this was certainly true in the case of Akbar, and without elaborating much further on his remarkable character, we will now turn to the achievement that has brought him the greatest fame.

This was the creation of one of the finest schools of small scale painting the Orient has known with book page portraiture of world renown, even copied by no less an artist than Rembrandt. However, his copies, which are drawings of standing individuals, quite misunderstand the actual virtues of Mughal portraiture which are to be sought, not in sketchy suggestive realism, but rather in elegant linear precision and subtly modeled airless surfaces such as you would see in early Italian painting before the full development of *chiaroscuro* (atmospheric light and shade).

Mughal school is created with portraits even copied by Rembrandt.

Akbar's atelier had originally been brought to India by Humayun, headed by Mir-Sayyid Ali who came from the court of Shah Tahmasp, and who was probably followed by his famous father, Mir Musavvir, as well as the great master painter and calligrapher, Abd-as-Samad, who was put in charge of the workshop when it was brought to Delhi.

The first and most important work executed by this atelier in Delhi, which is regarded as establishing the creation of the Mughal School of India, was the *Hamza-nama,* a history of the early Islamic hero, Hamza. A truly monumental work, it contained around 1,200 illustrated pages of a large size, rarely seen in Persia and not repeated in India again under the early Mughal rulers, measuring about 27 × 20 and painted on cotton cloth which was then attached to the paper of the manuscript with writing on the reverse. This technique, never practised in Persia, will remind us of the many references to paintings on cloth which were then hung on walls as quoted from excerpts from the Gupta texts in Moti Chandra's book on the courtesans of India, mentioned in our introduction page 4. The production of this huge work is considered to have taken at least until 1580 during which time it is known to have been closely supervised by Akbar himself, although this was the period of his life when he was campaigning heavily to fulfill his dreams of empire, but such were the energies of this remarkable man that he managed successfully with a finger in every pie.

The *Hamza-nama* is painted on cloth, as in ancient India.

However, it must be remembered that Akbur was of all things most fond of painting which he is known to have studied at Kabul. There exists in the Gulistan Library in Tehran a painting depicting the young prince presenting a picture to his father, Humayun, which is signed by Abd-as-Samad, undoubtedly representing a painting produced by the young Akbar himself.

The style of the *Hamza-nama* will be taken up again at the end of this very brief sketch of the personalities of the four emperors responsible for the Mughal paintings contained in this book.

Akbar's influence on style of *Hamza-nama*, despite his campaigning.

It is sad to realize that at the end of this great man's life he was to face the insurrection of his son and heir, Prince Salim, the future Emperor Jahangir, who already in 1604, had moved himself to Allahabad, crowning himself with the title of Shah, although a reconciliation will take place between father and son before the great man was to pass away in 1605.

Akbar faces the insurrection of his son Salim.

Salim was crowned Emperor Jahangir (the Earth Seizer) the same year. His reign will not be distinguished by military exploits, nor by his political or administrative talents, but it will instead produce the finest period of painting of the Mughal school.

Salim crowned Emperor Jahangir, ruled 1605-1627.

Jahangir, a far less powerful personality than his father Akbar, self-indulgent and luxury-loving, deeply resented the domination of his father which caused his rebellion and removal to Allahabad where he is considered to have created his own fine atelier of painters. Possessed of a poetical nature with infinitely discerning aesthetic judgement, although sensuous and self-indulgent, his love of all aspects of the natural world is reflected in the paintings produced under his direction which

Jahangir, poetical and a lover of nature, produces the most exquisite moment in Mughal painting.

Kishindhya, who Rama has just mortally wounded with an arrow. In Pl.198, from the same series, Rama is in counsel with Siva and Brahma, with a group of most sensitively painted monkey gods lower right, and a gold painted fort or palace upper left background. The drawing and painting is again obviously by one hand, creating a unified tonality not always present in the Imperial examples. Pl. 199 shows an unusual attempt to represent a night scene lit by candlelight, with the contrast of the buildings and mountains appearing in the night light outside. Although belonging to the early seventeenth century, this is an unusual attempt at emulating European full chiaroscuro, but the success is only partial, and suggests that parts may have been copied from European paintings, datable to ca. 1630.

Pl. 199 Mother Nursing a Child, Mughal, ca. 1630, size $7^7/_8$″ by $5^1/_8$″, National Gallery of Canada, Ottawa. (23,560)

The example on Pl. 200, probably from a *Khamsa* of Nizami manuscript, is probably a provincial Mughal work of the early seventeenth century, copied from an Imperial manuscript. In a partially tinted painting, many figures both male and female gesticulate about Shirin who is mortally wounding herself upon the grave of Khusrau, tomb and arcades beyond, and much delicate vegetation with small cypress trees, then a European inspired landscape in the upper distance. The gesticulating male figures at left are in the rather heavy fluttering-drapery style seen in our Mughal portrait Pl. 187, probably inspired by Catholic copper engravings whereas the female figures at right are more truly Indo-Persian in their character, suggesting that the painter who put in the male figures at left may not have been the same artist who put in the female figures upper right.

Pl. 200 Shirin dies on Khusrau's grave or A Princess Committing Suicide at the Tomb of a Beloved, provincial Mughal, first half of the 17th century, size $8^5/_8$″ by $5^7/_8$″, National Gallery of Canada, Ottawa. (23.,552)

On Pl. 201 we see an exceedingly fine painting considered to be by Basawan representing the Vizier pleading for the life of a robber's son, from a *Gulistan* of Sa'di, dated to around 1595. Here is great spontaneity and action, fine subtle modeling with an expressive line throughout, along with harmonious tonality also seen in the architecture.

Pl. 201 The Vizier Pleads for the Life of the Robber's son, from a *Gulistan* of Sa'di, by Basawan, Mughal, ca. 1595, size $11^1/_2$″ by $6^1/_2$″, Los Angeles County Museum of Art.

In Pl. 202, in a jewel-like landscape filled with flowering plants and multi-coloured rocks of a most Deccani character, a group of equestrian hunters at left and fishermen above right are painted in beautiful jewel-like colours, with a group of equally jewel-like figures in a boat which approaches from the right across a diagonal of dark water tossed with a myriad of fish and birds. The painting retains some Persian features, especially in the rather stiff little seated prince in the boat, while some of the figures, such as the fishermen above, would seem to suggest the figural painting in late fifteenth century Bihzad. The colour and composition of this painting could hardly be surpassed. It is dated 1600 from an unidentified manuscript and is in the Freer Gallery of Art.

Pl. 202 Scene at a Riverbank, from an unidentified manuscript, Mughal, ca. 1600, size $6^7/_8$″ by $4^{11}/_{16}$″, Freer Gallery of Art, Smithsonian Intitution. Washington, D.C. (45.28)

On Pl. 203 we have a famous painting of the Emperor Jahangir surrounded by his courtiers, which is considered to have been painted by Abu'l Hasan. These remarkably well painted portraits, however, have almost certainly been painted into a scene which was prepared by other hands, which has resulted in a lack of unity. Although some of the portraits in this painting may have been entirely by the hand of the master, such as the fine figure of Jahangir (although his hands are rather stiff) and the fine three-quarter portrait of the individual in purple-gold brocaded coat bottom center, the master has probably painted in only the heads of the other individuals with bodies executed by assistants. This causes the entire conviction of some of the figures to be lacking, such as in the rather wooden shoulders and back of the minister in yellow, left center, with red and white turban—this in spite of the excellence of his portrait head. However, all of the figures were probably inserted in a landscape prepared by someone else which interrupts the atmospheric tonality of the scene. In the upper right hand corner of this painting we see a head peering into the scene which might have been painted by an Italian, much in the style of Titian as we have already mentioned, on page 154. In green cap or turban and black mustache and beard, the technique of this painting is quite different from other Mughal paintings. Here the modeling is executed with soft *sfumato* shading rather than by the extremely subtle surface modeling which creates the volume of a face or form without diffusing it by atmospheric softness, as in all the other heads in this painting. The falconer in yellow coat and white turban

Pl. 203 Jahangir and Courtiers, by Abu'l Hasan, Ajmer, Mughal, ca. 1615-16, size $6^{11}/_{16}$″ by $4^7/_8$″, Freer Gallery of Art, Smithsonian Institution, Washington, D.C. The individuals in the Darbar scene of Pl.203 are identified by Dr. Richard Ettinghousen in *"Paintings of the Sultans and Emperors of India"* in the Lalit Kala Akademi, 1961. (46.28)

Head in upper right hand corner of Pl. 203 is discussed.

On Pl. 193 the stocky individual, rather stiffly holding his sword against a gloriously toned sunset sky with ground filled with beautifully flowering bushes, presents us with a rather uninspired personality, yet painted with exceptionally fine draftsmanship of much subtle refinement. Many highly realistic well-drawn portraits such as this example appear in the albums of Shah Jahan when representing non-Imperial individuals. The reason may be sought in the fact that these lesser people were willing to stand or sit for their portrait and were relegated to the work of one artist.

Pl. 194 shows the very height of Mughal portraiture. This superb example, probably by Hashim, ca. 1625, perhaps represents Mir Rustam who died in 1641. Although the gentleman is already elderly the extreme delicacy and refinement of the painting would seem to place it not later than 1620, although of course such painting did still take place at a later date. The subtle modeling of the face and beard, the heavy set neck and shoulders and the delicate hands are most expressive of personality while the refinement of line throughout and magnificent jewel-like colour make it one of the finest early Mughal portraits.

The painting on Pl. 195 representing a lion at rest in the bullrushes, with birds flitting about, is an interesting example of the retention into a very late period of pictorial elements introduced into India by the early Sultan invaders, who set up workshops of painting in India to a great extent drawn from the large numbers of artists and artisans in the country. We can only refer you to the cover design of *Persian Painting*, 1961, by Basil Gray, where two lions instead of one are seen among the bullrushes. In this painting one may see that the idea of a large lion reposing among tall grasses filled with birds is comparable to the two large lions seen amidst bird-filled bushes on the cover of *Persian Painting* by Basil Gray, which he dates 1298, and which he informs us to have been painted in the early Mongol capital in Azarbayjan about 70 miles south of Tabriz. Although the Sassanian or Chinese derived curls of Mr. Gray's lion have given way to fuzzy looking fur in our example, an outline persists around the open jaws of Mr. Gray's lion that is also a feature in ours, and although our lion is happily resting with hind legs in the air without a mate, the large lion amidst the rushes must be said to be a similar idea.

In Pl. 196 we have one of the loveliest most lyrical portraits in the book, from the Deccan but under strong Mughal influence of the period of Jahangir, painted around 1615 and now in the Freer Gallery of Art. We see an elegant youth reading a manuscript in red coat with fur collar and green fur-trimmed hat, seated one knee up on a gold throne in a charming flower and delicate leaf-filled landscape which seems to melt into the high distance of clouds and strips of blue sky, with his falcon on a gold perch at his feet. The painting achieves the greatest refinement and the face, although appearing quite solid, is modeled with almost invisible delicacy producing a bas-relief-like effect as one sees in early Italian painting, and the line maintains its elegance throughout. Although the portrait has an inscription of Muhammad Ali, Dr. Atil agrees with us this is probably not the same Muhammad Ali of the Boston Museum painting of a poet in a garden although the Boston example is also imbued with the flowery charm of a Deccani painting. A certain stiffness, especially in the handling of the figure, makes it seem improbable that both paintings could be by the same hand.

On Pls. 197 and 198 we have two pages of the so-called provincial Mughal school, meaning not painted in the Imperial atelier. They are thought to have been produced at Agra, where, according to Mr. Milo Beach, many works were made which were not destined for the Emperor's own library. It is precisely because these works were not produced by the Imperial atelier for the Emperor's own library that they possess a freshness and spontaneity not usually seen in the large Imperial copies, and it may be assumed that they were painted by one hand only. In the example on Pl.197, the luxuriant flora surrounding the temples is alive and fresh and the monkey gods (as both pages are from a *Ramayana* series) are represented with spirit and delicacy. Rama and Laksman approach Balin, the monkey king of

Pl. 193 A Nobleman, Mughal, mid-17th century, slightly reduced, Private Collection.

Pl. 194 Mir Rustam of Qandahar, Mughal, early 17th century, size 6⁹/₁₆″ by 3³/₄″, Los Angeles County Museum of Art. M.78.9.14.

Pl. 195 A Lion, Mughal, ca. 1630, slightly enlarged, New York Private Collection.

Pl. 196 A Youth Reading, by Muhammad Ali, Mughal, ca. 1610, 6¹³/₁₆″ by 3⁷/₈″, Freer Gallery of Art, Smithsonian Institution, Washington, D.C. (53.93)

Pl. 197 Rama Kills Balin, from a *Ramayana* series, sub-imperial Mughal, size 11″ by 7¹/₂″, Los Angeles County Museum of Art.

Pl. 198 From a *Ramayana* series, sub-imperial Mughal, ca. 1610, size 11″ by 7½″, National Gallery of Canada, Ottawa. (23,553)

On Pl. 182 we have a rather unusual subject from a late Akbar manuscript representing a Prince being drawn across his courtyard by two attendants with another two who fly along at the bottom with a distant European inspired scene appearing over the dark brown wall and large dark tree. This might represent the game evidently played by Peter the Great when renting an English noble's house for the purpose of studying shipbuilding in England. He was known to have created not only tremendous damage to the furnishings of the house but to have destroyed the hedges by being pulled about in a wheelbarrow by his followers. Retaining some of the Persian character seen in the *Hamza-nama,* naturalism has advanced to the point of creating a very real atmosphere in this little scene.

Pl. 182 Mentioned.

On Pl. 186 we see very pronounced European influence, perhaps to the point of representing a European copy, where the individual seated on a tiger's skin under a typically gnarled and decorative Mughal tree is playing an Indian instrument— the bagpipes and the harp with a separate soundbox, with heavily modeled garments and an exceedingly European looking scene in the distant right. In spite of the European characteristics, including the individual himself, line and modeling throughout conform to the Mughal manner, although the landscape in the distance has developed the sketchy impressionism of a Flemish watercolour.

Pl. 186 A Musician playing bagpipe and harp with separate soundbox, Mughal, ca. 1590, Los Angeles County Museum of Art. M.80.6.7.

On Pl. 187 is a portrait showing a turbaned man with cane and book, strongly suggestive of the European influence brought in by copper engravings from Goa of Catholic subjects in its emphasis on heavy folds. The costume suggests that of a priest except for the turban. The minutely fine painting of the face is in contrast to the rather clumsy handling of the body, the heavy inarticulate hands and arms, with feet attached out of axis to the figure, suggesting that the painting might have been executed by an early sixteenth century Deccani artist, with a head possibly even inserted by an Italian artist, or perhaps a copy of one. The face suggests a European, also the background appears washed in watercolour, either by a European artist or in imitation of one.

Pl. 187 A Scholar with cane and book, Mughal, ca. 1590. Approximate size, Private Collection.

On Pl. 188 a servant in red is carrying a Chinese blue and white vase of the type imported into both Persia and India in the sixteenth-seventeenth centuries. The face suggests the overmodeling introduced through the last Baroque copper engravings such as the enlarged drawing Pl. 189 (again compare the subtle modeling of the portraits Pls. 183 and 184 and especially Pl. 193) but the strong Mughal line is in evidence throughout in the delicate line of the sash and in the strands of the individual's hair, as well as in his garment and feet. The enlargement Pl. 189 is a typical example of the Indian artist's attempt to emulate a European copper engraving. Here the forms throughout are lost in a fuzzy blur, attempting the atmospheric effect of high Renaissance chiaroscuro. The seated prince on Pl. 190, although to all intent and purposes a typical Mughal portrait, with the body showing through the transparent white garments with the line here represented in white, nevertheless, in the face and even in the tree, possesses a certain watery sketchiness which is not quite the solidly modeled form of the best Mughal painting. One almost feels that a European watercolourist might have had a hand in the face and the tree, as well as the sketched-in background. On the other hand, in the two seated princes in Pl. 191, although probably copied from a European painting, the treatment throughout is linear and the modeling solid though subtle.

Pl. 188 A servant holding a Chinese blue and white vase, Mughal, ca. 1690. Approximate size, Private Collection.

Pl. 189 Tinted drawing of a symbolic figure, Mughal, ca. 1590, $4^5/_{16}$″ by $2^5/_{16}$″, Los Angeles County Museum of Art. L.69.24.235.

Pl. 190 Seated Courtier with Rosary, by Jaganath, Mughal, ca. 1600, $3\frac{1}{2}$″ x $5\frac{1}{2}$″, Virginia Museum, Richmond, Virginia. (68.8.60)

Pl. 191 A Religious discussion, attributed to Manohar, Mughal, ca. 1600-1605, size $3^{15}/_{16}$″ by $4^1/_8$″, Los Angeles County Museum of Art. M.818.4.

The portrait Pl. 192 is most unusual and difficult to identify, perhaps painted by a Turkish artist in the Deccan. The turban is Deccani and the face suggests a Turkish individual who wears a gold brocaded coat of typical Turkish design over a green silk undergarment brocaded with graceful scrolling floral ornament, which ornament also appears on his deep blue trousers. As Mr. Gray points out, his sword is European. Sir Thomas in the Journal tells us how pleased Emporer Jahangir was with the gift of a European sword, wearing it all day. This unusual painting has been included because of the extraordinary interest of the textile design and because it suggests the Turkish presence in the Deccan.

Pl. 192 Portrait of a Turkish noble, Mughal, early 17th century. Approximate size, Private Collection.

Pl. 173 is an extremely beautiful tinted drawing representing Prince Salim, to eventually become the Emperor Jahangir, resting during a hunt. Authorship has been attributed to Miskin, and that this is all by one hand could hardly be questioned. It is considerably modeled, with a unifying tonality and much suggestion of perspective, as all figures and rocks diminish in size as they disappear into the upper distance. European influence appears present in the seated figures lower left. The figure of Prince Salim, seated on a rock by his great horse, would appear to be a very fine portrait.

On Pl. 174 in a double floral border of scrolling flowers, painted in gold against blue on the larger outer border and against cream on the inner border, is an elegant tinted drawing of a kneeling individual. With turban worn over one ear and fur-collared coat, the long arms of which hide his hands, one of which holds a rosary, he kneels, reading from an open book, probably a Koran. Above him is a simple raised canopy and to the right on the floor, in a gold candle stick, burns a single candle. On the floor center from, a gold dish probably contains some food. With subtle line and modeling, the character of this reading individual is wonderfully expressed. This painting may be later and from Bikaner.

The examples Pls. 175 through 178 show Mughal portrait draftsmanship at its best. In Pl. 175, the character of this slightly fleshy, gentle and deeply serious individual is wonderfully conveyed, as is the acid patience of the older minister on Pl. 178. The delicacy and expressiveness of the hands should be noted. The hands of the more austere looking person show us hands that might almost suggest the knuckle-cracking hands of Anna Karenina's husband, Karenin. The portrait drawing, Pl. 176, is among the finest small portraits in pencil or ink. The seated individual, so delicate and sensitive in its line and modeling, could hardly have more character and individuality, as is even more evident in the enlargement Pl. 177.

Pl. 179 shows a large painting of a complicated scene of much action and drama from an *Akbar-nama* representing a palace which is in flames. We have again what might be called a composite painting, done perhaps by several different hands although the results are extremely beautiful and effective. When one looks at the two portraits, Pls. 180 and 181, especially the Falconer in yellow coat and white turban, black beard and mustache standing against a dark background, one can see the vast difference that exists in the finest Mughal portraiture when compared to those very large works with many figures, mostly by different hands. Here the tonality and life of the portrait would suggest a Holbein, the character of the face is deeply expressive as is the entire painting of the figure, although the body is painted with a less finished treatment than the head. In Pl. 181, the individual in a richly brocaded coat of a very detailed scene of animals in a landscape, holding a great falcon on his gloved hand, though lacking the incisive character penetration of Pl. 180, is a masterpiece of design and colour.

The three portraits, Pls. 183, 184 and 185, are among the finest and most expressive. All three may come from the small album commissioned by Akbar which he had ordered to be painted of his various ministers, although some may have been painted after his death. It was Akbar's intention that they should be as realistic as possible in order that he might determine the character of the individuals, as we have already stated. One would not imagine that he would have much difficulty in judging the character of this rather glowering individual, on Pl. 185. Slightly enlarged, and apart from revealing his nature, we are allowed to enjoy a most beautiful example of painting, with a colour throughout that simply delights the eye. The small dark individual in white with a long cane Pl. 184 standing above his gold plate filled with jewels, against a gold sunset sky, has a solid character, as he folds one reassuring plump hand over the other. He is, of course, the guardian of the jewels and probably an Ethiopian. The old gentleman with long cane, the example on Pl. 183 is also very much a character, while pleasing us, at the same time, as a handsome design of form against toned green background. All the paintings thought to come from this small album of portraits are painted with jewel-like colours.

Pl. 173 Prince Salim Resting during a Hunt, Attributed to Miskin, Mughal, ca. 1604, size 9$^5/_{16}$" by 4$^9/_{16}$", Los Angeles County Museum of Art. L.69.24.283.

Pl. 174 Sleeping Scholar, Mughal or possibly Bikaner. Approximate size, Private Collection.

Pl. 175 A Courtier, perhaps by Balchand, Mughal, ca. 1620-1640, slightly enlarged, Private Collection.

Pl. 176 Seated Man Praying With His Rosary, Mughal, ca. 1620, approximately life size, Private Collection.

Pl. 177 Detail of Pl. 176, enlarged.

Pl. 178 A Courtier, possibly by Hunhar, Mughal, ca. 1640, approximately 11$^1/_2$" × 7$^1/_8$", National Gallery of Canada, Ottawa. 23.554.

Pl. 179 The Siege of Champanir, from an *Akbar-nama* manuscript, Mughal, ca. 1604, size 14½" by 9$^3/_8$", Los Angeles County Museum of Art. M.78.9.6.

Pl. 180 A Falconer, Mughal, late 16th century, 8$^5/_{16}$" x 16", National Gallery of Canada, Ottawa. (23.555)

Pl. 181 A Falconer, Mughal, early 17th century, size 5$^7/_8$" by 3$^3/_4$", Los Angeles County Museum of Art. L.69.24.27.

Pl. 182 A Prince Drawn By His Courtiers Through the Palace Grounds, Mughal, ca. 1605, slightly enlarged, New York Private Collection (mentioned at top of page 160).

Pl. 183 An elderly Courtier, Mughal, ca. 1620, (slightly enlarged), Private Collection.

Pl. 184 The keeper of the jewels. Private Collection.

Pl. 185 A Courtier, perhaps from the Akbar manuscript of portraits, Mughal, ca. 1605, slightly enlarged, New York Private Collection.

Pls. 162 and 163 show two pages from a *Jami-al-Tawarikh,* in the Los Angeles County Museum. Pl. 162 represents a procession of Mongol warriors in a light and airy landscape with rocks, running figures and a large tree reminding us of the *Hamza-nama,* whereas the miniaturesque treatment of the temples or palace scenes upper left and right, although the subject matter is Indian, suggest that they might be inspired by European paintings, probably Bible paintings on vellum or paper that were arriving in India by the quantities although paintings on canvas and wood were undoubtedly coming as well.

The painting on Pl. 163, although from the same manuscript, is rather different in style, the ladies of this harem scene are more enlongated and graceful than the Mongol running figures at left and the tiny Persian looking figures, probably representing children, are quite different in style from anything in Pl. 162. Also the large tree, instead of every leaf painted in detail as in the tree in Pl. 162, as is the case with all the trees of the 60 examples of the *Hamza-nama* in Vienna, has its leaves rendered by flat washes of colour. Flat washes of colour suggest European watercolour, but, although the ground is rendered with washes of colour in many of the *Hamza-nama* pages, it is never the case with trees where leaves are always rendered singly.

Pl. 164 through 178 show us a series of drawings with here and there a touch of colour. In Pl. 164 Mughal draftsmanship is most expressive in the obese form of a musician who appears quite carried away by what he is playing, now in the collection of Edwin Binney, III. Pl. 166 shows us a tinted drawing of Jahangir, already tired with age or dissipation, and an enlargement of the same appears on Pl. 165. This is one of the most forceful portraits of Jahangir.

On Pl. 167 we have a fine example of the Mughal artist's sensitive rendering of animals. In the style of Akbar or very early Jahangir, the savagery of these two bulls, drawn and modeled with subtle delicacy, could hardly be surpassed and the wild agitation of the surrounding figures tells their story. On Pl. 168 in a delicately drawn landscape of the late sixteenth century, a prince with followers of various kinds is seated in the center while a holy man, whom he has come to visit, is seated at right with his beads. Many of the figures will remind us of the *Hamza-nama,* but greater naturalism and modeling have taken place. The entire scene is drawn with a most delicate line with an attempt at aerial perspective as the figures diminish in size into the upper distance.

Pl. 169 shows us a drawing of the early seventeenth century. This extremely spirited drawing, entirely by one hand and quite undeliberated, will have between tossed Persian rocks upper right, a tiny scene of very European inspired order. Although executed with enormous spirit and action, the draftsmanship lacks the incisive elegance of line throughout which is always present in a Mughal painting and which is clearly to be seen in the example Pl. 168, leading one to almost suspect that it might have been by the hand of a European artist, although probably by an Indian deeply influenced by European painting. There is no actual proof of any European artist of repute visiting India in the early Mughal period such as the doubted trip of Bellini to Turkey, but it is more than possible that such might have been the case, not necessarily by an artist of fame as there probably were many fine artists who never achieved their own ateliers—always working for others.

On Pl. 170, in a delicately tinted drawing of many varieties of animals, we see the refined subtlety of the Mughal draftsman, dated 1590 by Milo Beach and 1600 by Basil Gray, which is in the Freer Gallery of Art and is attributed to Miskin. This example is in great opposition to the tumbling figures, Pl. 169. Pl. 171 is an example of a ''cut-out'' representng an elephant with his Mahut. Drawings of this nature were cut out and used for the purpose of tracing, which, of course, would lead to the mechanical character to be seen in some of the innumerable copies. In the small tinted drawing on Pl. 172, almost achieving full colour, we see a rearing elephant with Mahut, the subtle and clearly defined outline showing us the true character of Mughal painting. It belongs to the early seventeenth century and is in the Seattle Art Museum.

Pl. 162 A procession of Mongol warriors, from a Jami-al-Tawarikh manuscript, Mughal, ca. 1600, size 12½" by 8", Los Angeles County Museum of Art.

Pl. 163 The Harem Enclosure, from a Jami-al-Tawarikh manuscript, Mughal, ca. 1600, size 13½" by 8³/₈", Los Angeles County Museum of Art.

Pl. 164 A Vina player, Mughal, perhaps early 17th century, approximatley 5½ " by 3¼", Collection of Edwin Binney 3rd.

Pl. 165 An enlarged detail of a portrait drawing of Jahangir, Mughal, ca. 1620, size 4³/₁₆" by 2¹/₈", Los Angeles County Museum of Art.

Pl. 166 A portrait drawing of Jahangir, approximate size, Los Angeles County Museum of Art. L.69.24.272.

Pl. 167 Two Buffalos Fighting, attributed to Farrukh, Mughal, ca. 1605. Approximate size, Private Collection.

Pl. 168 A Prince with a Holy Man, Mughal, ca. 1595. Approximate size, Private Collection.

Pl. 169 The Youths Run Amuck, from an unidentified manuscript, Mughal, early 17th century. Approximate size, Private Collection.

Pl. 170 The Kingdom of the Animals, attributed to Miskin, Mughal, ca. 1595, size 9³/₁₆" by 4·¹/₁₆". Freer Gallery of Art, Smithsonian Institution, Washington, D.C. (45.28)

Pl. 171 An Elephant and Rider, a cut-out, Mughal, early 18th century, 9³/₈" by 13¹/₈", National Museum of Canada, Ottawa. (23.571)

Pl. 172 An Elephant and Rider, Mughal, mid-17th century. Approximate size, Seattle Art Museum, Seattle, Washington, Richard Fuller Collection.

tion of different shapes and colours, all expressed in a fine line with inner model-ling. The trees, crags, and lively action of the figures remind one of the *Hamza-nama* although still belonging to the later Akbar period, in style.

The battle scene in Pl. 156, a tinted drawing, has a certain stiffness in many of the figures and a lack of clarity in the composition. On the other hand, the hunt-ing scene on Pl. 157, although both paintings belong to the beginning of the seven-teenth century, has great life in the drawing throughout, not to mention the jewel like colour and the elegant and clearly readable composition. This suggests that the hunting scene, Pl. 157, is by one hand only, and to consider again that when that is the case the character of the entire painting is very much improved. Many very fine portrait-heads, obviously by the finest artists, have been inserted into paintings that have become to a certain degree more static due to this practice, such as one cannot help but feel to be the case in the extremely important Darbar painting Pl. 203, which contains a series of superb individual portraits considered to be by Abu'l Hasan.

The example on Pl. 158, from a *Shah-nama* representing Feridun striking Zahhak, must be by one hand. In this small brilliantly painted and lively palace scene we see ladies of the harem saved by Feridun who wields a gold ram-headed axe against the armed Zahhak while warriors and soldiers battle it out below. This scene of high action is painted with minute delicacy and possesses some traces of the Persian painter Bihzad who lived one hundred years earlier in Khurasan but whose influence was great and lasting. The wide outer border of animals amid rocks and flowering bushes may not have originally belonged to the painting which is probably also the case in Pl. 159, another small jewel-like painting of the beginning of the seventeenth century, from an *Akbar-nama*, which gives us a fine aerial view of a fort. Whereas Pl. 158 makes little effort to aim for a totally accurate perspective in its different planes of figural representation, Pl. 159 makes every effort to diminish the figures in the top distance, giving us an extremely minutely executed white throne or bed surmounted by a canopy around which tiny figures move about. The fort itself is rendered with much delicate descriptive detail with great attention to aerial perspective which, however, is not scientifi-cally accurate. The laws of perspective remain constant regardless of the angle from which the scene is viewed, but these laws were as yet unknown to the Mughals. However, this inaccuracy of perspective in no way hampers the effec-tiveness of the composition which is highly expressive of actuality and full of col-ourful detail.

On Pls. 160 and 161 we have two pages from two different *Babur-namas*. There are three separate manuscripts of the *Babur-nama* known in the world today with pages dispersed in different collections. Without identifying exactly which manuscript each one of these specimens may come from, suffice it to say that the example on Pl. 160 has many of the characteristics that one sees, either in a copy or in a painting by many different hands, as the draftsmanship throughout has far less conviction than in the pool building scene on Plate 161 where all of the figures at work in the scene are alive and full of action. The standing robed individual, undoubtedly representing Babur himself, is well drawn and expressive. The ex-ample on Pl. 160 entitled, "Horses Killed by Murrain at Chir," has an attribution to Sarwan. Without going into the probable accuracy of this attribution, or a study of Sarwan's style, it must be remembered that all written attributions to be found on Mughal paintings are not to be accepted in the same fashion as one would ac-cept a European signature. Not only is the style of writing too calligraphic in character for signature identification, but the habit which existed in the court libraries of attaching the signature of a copied manuscript as it would appear on the original would tend to make identification of artists from written signatures most unreliable. One may also observe in these two paintings the difference in tonality, wherein 160 is rather lifeless and 161 by contrast, appears to possess life and unity, leading one to conclude that Pl. 160 might be a copy, or at least painted by several hands.

Pl. 156 Battle scene, a tinted drawing from an unidentified manuscript, Mughal late 16th century, ap-proximate size, Seattle Art Museum, Seattle, Washington, Richard Fuller Collection.

Pl. 157 Hunting scene from an unidentified manuscript, Mughal, ca. 1600, size 13¼" by 8½", Seattle Art Museum, Seattle, Washington, Richard Fuller Collection.

Pl. 158 Page from a *Shah-nama*, representing Feridun striking Zahhak, Mughal, early 17th century, size 21 by 16". Los Angeles County Museum of Art.

Pl. 159 From an *Akbar-nama*, Mughal, early 17th century, approximately 21" by 16", Private Collection.

Pl. 160 Horses killed by Murrain at Chir, from a *Babur-nama* manuscript, attributed by Milo Beach to Sarwan, Mughal, ca. 1590, size 8³/₁₆" by 5¼", Private Collection.

Pl. 161 Babur encloses the spring at Istalif, at-tributed by Milo Beach to Sur Gujarati, Mughal, ca. 1590, size 8⁷/₈" by 11¼", The National Gallery of Canada, Ottawa. (23.551)

fish, as well as the beautiful tree, every elegant leaf painted in detail. The gesticulating merchant in red could also be seen in many pages of the *Hamza-nama* but the tonality and increased modeling carry the painting towards greater realism as will be the case in Pl. 149, a fanciful tree house scene. Two enormous hornets hovering below the couple drinking in the tree house, represent the disguised merchant and his confidante who are attempting to spy on his wife, whom he discovers to be really no more than a nymph as she sits drinking with her winged nymph companion. This explains to the disguised-as-a-hornet merchant why his wife doesn't act like a real wife, and all this takes place in a most beautiful and delicately designed leafy tree with tossed crags at left and a fine accompaniment of musicians to round out the story. One also sees the emergence from the *Hamza-nama* in the greater tonality and softness of modeling throughout.

In Pl. 150, illustrating the same book, we see a Maharajah enjoying great sport in swimming with his wives. The pool is surrounded by vegetation, with the walls of the palace below. The painting possesses a soft unifying tonality, but, although there is much attempt to tell a lively story, the draftsmanship of the figures and faces is not equal to the painting of the three females in the harem scene shown in Pl. 151, probably from the same manuscript, which indicates the great divergence in the ability of different artists of the same period and workshop. Here the yearning lady with outstretched arms is painted with the greatest delicacy, as are the two females below. This painting Pl. 151 retains an elaboration of tilework inherited from the *Hamza-nama,* but again the tonality is more naturalistic.

The following four miniatures, Pls. 152 through 155, are from a *Harivamsa,* a narrative genealogy of the God Vishnu, which is an assemblage of Hindu stories mainly dealing with the God Krishna which, (as Stuart Cary Welch points out in his description of pl. 10 in his book *Imperial Mughal Painting),* Akbar had translated by Bada'on to explain Hinduism to his Muslim courtiers in order to instill in them religious tolerance. They are dated by Stuart Welch to 1585-1590, and by Robert Skelton in the Victoria and Albert Yearbook for 1970, to 1590.

In Pl. 152 Balarama, brother of Krishna, is catching the demon ass Dhenuka. Full of action, reminiscent of the *Hamza-nama,* the contrast in values of the ground where Krishna is dashing, suggests a quite impressionistic treatment with flat washes of colour much in the same manner of a European watercolour, but the period would seem to pre-date the arrival of the great numbers of European paintings—most of them probably gouache and perhaps watercolour which Jahangir preferred over oil. This impressionistic style does appear in the *Hamza-nama* and in certain very early Akbar period painting, such as the cow with calf of Stuart C. Welch's *Imperial Mughal Painting,* fig. III, as well as the portrait he illustrates, fig. IV, of the same book.

In Pl. 153 the delicate, light and airy landscape showing the love of two white horses, owes much to the Deccan as well as the *Hamza-nama,* although the composition has become far more self-contained than the latter, but in Pl. 154 we see even stronger Deccani influence. Here Krishna, in gold crown and gold scarves, stands on a golden chariot driven by his galloping horses coming to the attack of a horde of demons, the main giant among them appearing tossed from the sky with his huge lumbering body falling at the left. In this landscape of exceptional delicacy and charm, three gods and perhaps the Maharajah himself are enshrined in flowering bowers in the European handled clouds above. The colouring and delicate charm of the landscape owes much to the Deccan.

Pl. 155 almost makes us think we are looking at a Brueghel were it not for the huge green lionheaded demon attempting to carry off Balarama in the upper right corner while Krishna himself is dashing into the picture at left. All these extremely excited figures which dash about, some on the backs of others, some swimming in the water below, some washing or drinking, create a beautiful composi-

Pl. 149 The Nymph Somaprabha, from a *Kathasaritsagara* manuscript, Mughal, ca. 1590, size 5¹/₈″ by 5³/₈″, Los Angeles County Museum of Art.

Pl. 150 Water sports, probably from a *Kathasaritsagara* manuscript, Mughal, ca. 1590, slightly enlarged, Private Collection.

Pl. 151 Harem scene, probably from a *Kathasaritsagara* manuscript, Mughal, ca. 1590, size 5⁷/₈″ by 7⁵/₈″, Los Angeles County Museum of Art.

Pl. 152 Balarama catches the demon ass, Dhenuka, from a *Harivamsa* manuscript, Mughal, ca. 1585, size 11¹⁵/₁₆″ by 6¹⁵/₁₆″, Los Angeles County Museum of Art.

Pl. 153 The love of two horses, from a *Harivamsa* manuscript, Mughal, ca. 1585, size 11³/₄″ by 6⁷/₈″, Los Angeles County Museum of Art.

Pl. 154 Krishna slays a demon horde, from a *Harivamsa* manuscript, Mughal ca. 1585, size 11⁵/₈″ by 7³/₁₆″, Los Angeles County Museum of Art.

Pl. 155 Balarama kills Pralamba, from a *Harivamsa* manuscript, Mughal, ca. 1585, size 11¹³/₁₆″ by 7³/₈″, Private Collection.

Returning now to a discussion of the paintings reproduced in this book, in Pls. 142 and 143 we have two examples from a *Tarikh-i-Alfi,* one of the histories of the world which Akbar commissioned, which is referred to in the *A'in-i-Akbari,* an important contemporary account of the Mughal court.

Although executed in 1585-less than ten years after the completion of the *Hamza-nama,* the style of these pages is already noticeably different. The treatment of the buildings is more naturalistic and less brilliantly decorative, the Indian pointed coat has disappeared in favour of the Persian coat, but the trees seen in the *Hamza-nama* remain, and, although violent action is the subject in Pl. 142, it is no longer rendered with the turbulent excitement which one sees in the *Hamza-nama;* instead, the composition, even though interrupted by the floating text, is contained and well-balanced. Again, as in the *Hamza-nama,* one sees Persian looking figures interspersed, but more naturalistically inspired, often of a rather heavy sort, with fluttering drapery that may represent European influence, very likely brought in by the copper engravings circulated by the Portuguese as they were first brought to Goa in Portuguese ships from the Catholic Spanish Netherlands as already pointed out.

The following four reproductions are from a Jahangir album which are variously dated before and after the death of Akbar, eleven pages of which are illustrated by Milo Beach in *The Grand Mogul,* with six rectos and five versos. Some of the finest portraits painted in the Jahangir period are to be seen in the border of our Pl. 144 of which Milo Beach reproduces a fragment, page 47, of his *Grand Mogul.* These portraits epitomize the subtle linear type of painting which we described in our Mughal introduction. Modeled with extreme delicacy, the flowing line expresses the inner content, as in early Italian painting, a characteristic that imparts to Mughal painting its particular charm and beauty. On Pl. 145, the recto of Pl. 144, which Milo Beach dates to 1591, attributing it to Abd-as-Samad and Muhammad Sharif, (whereas he attributes the portraits in the margins of our Pl. 144 to Govardhan ca. 1610), we see hunters of a highly Persian character on horseback, passing through a rocky landscape with Chinese crags tossed against a gold sky, although a tiny hunter, kneeling shooting in the foreground, represents the fully developed Mughal style that transpires after paintings are brought in from Europe by Sir Thomas Roe, replacing the fluttering drapery manner that was inspired by the copper engravings of European religious subjects as well as late sixteenth century Portuguese and Italian religious painting. These styles, however, will continue to appear together as will be seen on our Pl. 145.

The Naughty Elephant Pl. 147, who tries to escape through a rocky landscape with his *mahut* (rider) at right, is already in the developed Mughal style of the small figure kneeling with gun Pl. 145, although the fellow holding the elephant's foot might be closer to the more Persian looking horsemen in Pl. 145, but the verso of Pl.147, shown in our Pl. 146, possesses a figural border surrounding a page of calligraphy that is entirely taken from a European copper engraving. This monochrome gold-painted border has been published by Richard Ettinghausen in 1961 in a Festschrift for Panovsky, fig. 16 and 17. The Persian inspired twisted crags that rise at the right will appear all through early Mughal painting and are most characteristically seen in the *Hamza-nama,* and also characteristic of the *Hamza-nama* is the great tree at left with precisely designed leaves. Milo Beach has attributed this painting to Farrukh and dated it to 1600.

Pls. 148 through 151 represent four colourful paintings that have been cut from a larger page with calligraphy of the *Kathasaritsagara,* or "Ocean of Stories," a collection of Hindu folk legends compiled about the twelfth century. In Pl. 148 the beautiful Siddikari, up in the tree, has outsmarted a thief whom she manages to hang after he has attempted to rob her of what she had in turn robbed a merchant, only to be found by the very merchant she robbed who is rushing in from the right to give her what she deserves. In this extremely colourful landscape we see many influences from the *Hamza-nama,* not only the lady in the tree but the green flowering sprays below, the tossed rushing water with swimming turtle and

Pl. 139-40 & 141 are described at bottom of page 151 and top of page 152.

Pl. 142 The Palace attacked. From a *Tarihk-i-Alfi* manuscript, recto, Mughal, ca. 1585, size 17″ by 9³/₄″, Los Angeles County Museum of Art.

Pl. 143 The sleeping man discovered, from a *Tarikh-i-Alfi* manuscript, recto, Mughal, ca. 1585, size 16¹/₆″ by 8³/₄″, Los Angeles County Museum of Art.

Pl. 144 Page from an album of Jahangir, verso, margins attributed to Govardhan, Mughal ca. 1608, size 16¹/₈″ by 9⁵/₈″, Los Angeles County Museum of Art.

Pl. 145 Hunting scene, again from an album of Jahangir, recto, attributed to Abd-al-Samad, Mughal, ca. 1591, size 16¹/₈″ by 9³/₈″, Los Angeles County Museum of Art.

Pl. 146 Page from an album of Jahangir, verso, Mughal, ca. 1600, size 16³/₄″ by 10¹/₁₆″, Freer Gallery of Art, Smithsonian Institution. (56.12)

Pl. 147 A Chained Elephant from an album of Jahangir, recto, attributed to Farrukh, Mughal, ca. 1595, size 16³/₄″ by 10¹/₁₆″, Freer Gallery of Art, Smithsonian Institution. (56.12)

Pl. 148 The Cunning Siddhikari, from a *Kathasaritsagara* manuscript, Mughal, ca 1590, size 6¹/₂″ by 5¹/₄″, Los Angeles County Museum of Art. (M.78.9.12)

However, had Jahangir's artists been able to copy Roe's painting as well as the European-appearing portrait head, very much in the style of Titian, inserted top-right of our representation of a Darbar Scene, now in Freer and reproduced on our Pl. 203 dated by Dr. Richard Ettinghausen to 1615-1616, or the two black-bearded sultans that peer out at us from the bottom of the companion page to Freer's Darbar Scene, which painting is reproduced, no. 27, in *The Grand Mogul* of Milo Beach (1978) now in the Walters Art Gallery of Baltimore, and illustrating the presentation of a book, Sir Thomas Roe would never have discerned his own painting from those painted by Jahangir's artists—no matter what light he saw them in.

Possibility that a European artist might have occasionally inserted a portrait head in a Mughal painting.

Although no artist of renown is known to have visited India in the early seventeenth century such as the (now doubted) visit of Bellini to Persia in the fifteenth, some artist of lesser repute may well have, and if Jahangir were aware of his presence he would certainly have induced him to demonstrate his ability which could have been in the case of painting him a head or two in one of the paintings produced in his atelier. It must be understood that Jahangir would always have had a much higher opinion of his own artists so that the name of any such person would probably not have been preserved. Sir Thomas tells us in his Journal that Jahangir sat for his portrait by an artist named Hatfield, and we are told that an English painter-adventurer named James Story was imprisoned in Goa in 1583, receiving his freedom by becoming a lay brother and painting frescoes for the local church *(Early Travels in India,* by William Foster, pages 2-3).

R. Eddinghausen gives us an inscription of the head top right in Pl. 203 as ''Ancient Emperor of Rum''. Mr. Gray points to its resemblance to a portrait of Charles V by Titian in the Prado. A copy could have been sent to Jahangir and then copied into this painting, either by an Indian or a visiting European artist.

Mughal artists may have made every effort to be as accurate as possible in their copying, and in those examples which we know to be more or less direct copies, the results will often be extremely exact but the European oil paintings would have been robbed of their atmospheric *sfumatura,* or softness, and instead a sensitive but firm line would enclose all the forms with delicate but solid inner modeling. This will be most typically seen on Pl. 211, where four ascetics are seated on a platform in the open before what appears to be a Flemish landscape in the background.

Mughal artists in copying European painting convert the *sfumato* style to one that is purely linear even if heavily modeled.

The paintings belonging to the period of Jahangir possess great delicacy in the treatment of the most minute detail, whereas, in the period of Shah Jahan, the delicate and refined emphasis on naturalistic detail will be replaced by a taste for more sumptuous and lavish effect. A characteristic of the reign of Shah Jahan or later periods will be seen in the handling of the sash or *"kamarband."* In early examples, the sash will be twisted naturalistically at the waist and then fall in free, rhythmic folds. The tendency in the period of Shah Jahan will be towards a more formal and schematic treatment of the folds, giving full attention to the gold brocaded ornament. Portraits also tend to become less alive and inspired, such as the portrait border on Pl. 213 of our book which, however, frames one of the finest, most alive and subtly painted portraits in the book, leading one to conclude that the virtue of the individual painting will depend on the artist who painted it, whether working entirely alone and free to use his own judgement.

Greater formality in the Imperial portraits of Shah Jahan.

Although the famous portraits of Shah Jahan will be of a more formal order, of course appropriate to an imperial presentation, they achieve a magnificence and richness hardly to be surpassed and a great body of fine painting will take place under this emperor.

Shah Jahan, 1627-1657, the most glorious and sumptuous period of Mughal painting.

Aurangzeb, who imprisoned his father at Agra Fort, proclaiming himself emperor in 1657, although his father lived on until 1666, was a rather austere character, lacking the frailties of his predecessors but also their love for painting. As we have already mentioned, this started the decline of the Mughal school.

Aurangzeb (ruled 1658-1707) brings the great period of Mughal painting to a close.

as well as copper engravings were brought to India already in the time of Akbar, but probably most plentifully in the reign of his son, Jahangir, who was already an ardent collector of paintings as a young man.

Sir Thomas Roe, James the First's ambassador to India, 1615-1619, in his journal, tells us of seeing paintings of the King of England, Princess Elizabeth, and several other English notables placed behind Jahangir at his Darbar Imperial Audience; he also gives us a list of presents and curiosities that would be acceptable in India to give or sell. "Choice pictures, especially histories, or others that have many figures, as church work, night work or landscape, but good, for they understand them as well as we." Then he goes on to say, (page 77 of the journal) "Here are nothing esteemed but of the best sorts: good cloth and fine, and rich pictures, they coming out of Italy over land and from Ormus." Again (on page 99) ". . . Pictures, lardge . . . but they must be good, and for varyetye some story, with many faces, for single to the life hath beene more usuall."

This gives an idea of the quantity of European paintings which were arriving in India, and to illustrate Jahangir's avid interest in European paintings as well as the high opinion he held of his own court painters, we quote the following stories from the journal. On page 189 of the journal Sir Thomas tells us "that I had a pickture of a frend of myne that I esteemed very much, and was for curiositye rare, which I would give His Majestie as a present, seeing hee so much affected that art." Sir Thomas was hard pressed to persuade the emperor to hurry up with ". . . the sealing of our priviledges, for that our ships were ready to arrive . . ." In another part of Sir Thomas' journal (Addl. M.S. 6115, f. 276) we learn that the painter thus characterised was Isaac Oliver the celebrated miniaturist (1551-1617) and that it was a "smale limned picture of a woeman" and that it cost in England six pounds and would have sold in India for 150 rupees. Roe reports that the emperor ". . . tooke extreame content, showeing it to everie man neare him . . ." and sent for his chief painter demanding his opinion, whereupon Jahangir's painter bragged that he could do as well.

Sir Thomas Roe speaks of the presence of European painting in India.

Sir Thomas protested that he knew no man in Europe who could but the man who had painted it. ". . . Nay, said the King, I will call four paynters, my cheefe woorke men, and what will yow give mee if they make one so like, that yow shall not knowe your owne?" Sir Thomas managed to wriggle out of this wager but he tells us that several days later "At night hee sent for mee, beeing hastie to triumph in his woorkman, and showed me six picturs, five made by his man, all pasted (probably lightly attached) on one table, so like that I was by candle light troubled to discerne which was which; I confesse beyond all expectation;" although eventually Roe picks out his (page 199).

Akbar attempts a wager that Sir Thomas cannot detect his miniature from copies made by his court painters.

Sir Thomas with great difficulty finally discerns his own.

Roe tells us in the Journal about two other pictures in the following manner, (page 222) "At night about ten of the clock hee sent for mee. I was abedd. The message was: hee hard I had a picture which I had not showed him, desiering mee to come to him and bring yt; and if I would not give it him, yet that hee might see yt and take coppyes for his wives. I rose and carryed yt with mee. When I came in, I found him sitting crosse leggd on a little throne, all cladd in diamonds, pearles, and rubyes . . . his nobilitye about him in their best equipage, whom hee commanded to drinck froliquely, severall wynes standing by in great flagons."

Akbar, clad in diamonds, pearls and rubies sits on a little throne commanding his nobility to "drink froliquely" as Sir Thomas brings him two paintings at night.

Apparently Jahangir was astonished by one, a miniature of a lady, possibly Sir Thomas's wife and was bound to have it, although he did not care for the other painting Roe had with him which Roe calls a french painting which was probably in oils.

As Roe was reluctant to part with the painting of the lady saying that she was a dear friend, and implying that she was no more although Sir Thomas' wife, probably the subject of the painting, still lived, the emperor again asked that he might have the painting copied to give to his wives, and, if Roe could tell his from the copies, he could keep it. The outcome of this story doesn't appear in the Journal.

hardly be described in words.

The main body of late sixteenth and seventeenth century Mughal painting is not clearly divisible into separate schools in spite of the wide divergence in the character of these three emperors, as the artists who worked on them continued in the services, in some instances, of all three individuals. Therefore the paintings in this book will be arranged, not according to reign, but according to stylistic relationship.

A word must be said regarding the actual technique of Mughal painting. Using a very fine brush, sometimes hardly more than one hair, they used ground pigments modified with white to lighten the tone instead of letting the paper lighten the tone as in watercolour, with a glue size much as in modern gouache. This technique, also used in fifteenth century European Bible painting, is very similar to dry tempera (ground pigments mixed with yolk of egg, and used opaquely with white pigment admixture) of early Renaissance Italy. This technique was admirably suited for a painting style that would concentrate on line, where the outline of all form would be essential to the composition. The expressive line of the fine Mughal draftsman was sensitive enough to suggest the form contained within the outline, and although the Mughal painters, much under the influence of European painters, at times indulged in heavy dramatic modeling and, to quote B.G. and D.B. in *Painting of India,* "exhibiting his skill in chiaroscuro, according to Italian Mannerist prescription." True atmospheric chiaroscuro, with the losing of all outlines in shadow, was not realized, and in all fine Mughal painting outline, sensitive or strong as the case may be, but always expressive, will remain the essential characteristic of the painting. Interestingly, there is a quotation from the early Italian artist, Piero della Francesca in Michael Baxandall's *Painting and Experience* in fifteenth century Italy, which might have been directed towards the making of a Mughal painting. "By 'disegno' " (having in Italian a meaning for both drawing as well as design) "we mean profiles and contours which enclose objects." Europe soon included oil in the egg tempera emulsion, then oil glazes and finally full painting in oil, but as paper could take nothing heavier than gouache which produced a less lustrous finish, the Mughal artist compensated for this by burnishing his painting with a hard rounded stone such as agate, placing the painting face down on a hard flat surface and rubbing it with the rounded stone from the back. Some remarkably lustrous and rich effects were achieved by this method.

The technique of Mughal painting.

Gouache technique is enriched by burnishing with a hard stone.

Europe continued rapidly towards the fullest representation of reality, from the sensuous poetry of light that caresses the form of Titian to the drama of light that rises out of darkness in Rembrandt. Yet the simple charm and elegance of these Mughal portraits was such that even the world's finest painter, Rembrandt, made a copy of several, but interestingly enough, the sketchy style of his drawing, so moving in his own etchings, applied to the Mughal copy, by robbing the original of its elegant outline and subtle modeling, put an end to its purpose for existing.

After the exciting and flowing draftsmanship of most of the *Hamza-nama* pages, whose powerful and dramatic compositions could hardly be surpassed, the innumerable manuscripts of histories and heroic tales of various sorts prepared under Akbar's later direction will develop a much more polished style. Although the innumerable scenes of battle and beseigings of forts and castles will often become exceedingly complex, they will almost always possess a beautiful order and clarity. Design, a particulary strong Indian talent, will only break down in some of the Imperial paintings of court life, under Jahangir, and most especially under Shah Jahan, when the purpose will be to present official portraits of famous notables, rather than to tell a story with vivid life and vitality.

Great realism and lively rhythmic line of the *Hamza-nama.*

An increasingly realistic approach to painting will take place under the later Akbar period, tonality and modeling will come closer to the appearance of nature, not as yet really attempted in the *Amir-Hamza.* It is known that European painting

Greater refinement and elegance in later Akbar style, with increasing realism.

in the later, smaller and vastly more numerous books which Akbar, in his more mature years, will commission his atelier to execute on all manner of subjects.

As Mr. Gray and Mr. Barrett point out in *Painting of India,* these pages are filled with dynamic movement often appearing to be of such violence that the scene can hardly be contained within its margins as some of the action is cut by the edge of the frame. Another important feature mentioned by these authors, aerial perspective (an early device in Central Asia as well as Persia, probably originating from China), very much enlarged the field of operation to include both the inside and outside of the buildings and forts, with many of the figures represented so near to the picture plane as to be almost frightening, especially as some of these great looming figures are tremendous giants of quite terrifying appearance.

Violent action even spreads into outer margins.

Aerial perspective enlarges the field of operation.

One cannot help but observe the magnificently decorative compositions in these *Hamza-nama* pages. The architecture, which is strongly designed for maximum decorative effect, does not cease to possess its character as a building to be entered and walked about in, which is quite different from the flat stylization of Persia, and is a brilliant development of a feature which we have already mentioned on page 15 where we discussed the *Laur Chanda* folio in Manchester, page 69 of Douglas Barrett and Basil Gray in *Painting of India.* In speaking of the already typically Indian character of the buildings one can again only refer to the same book, *Painting of India,* where it is pointed out, in speaking of their example reproduced page 76, that the rich bracketed capitals and chevroned slender columns are reminiscent of Man Singh's palace inside the fort of Gwalior and that the faceted and staged minaret with finial top is related to the mosque buildings at Ahmedabad. This further emphasizes the Indian character of the *Hamza-nama,* and the female figures with their energetic action, seen on these different pages, as well as their costumes, are Indian and resemble early painting in the Deccan.

Pre-Mughal functional character of architecture exists in *Hamza-nama* as in Laur Chandra folio in Manchester.

Deccani influence in *Hamza-nama.*

The rich flora seen in these paintings are for the most part rather naturalistic in spite of their decorative character, which will suggest the vegetation in the beautiful Nepalese *pata* representing Tara, in the Cleveland Museum of Art, which is derived from Pala painting and, of course, from the cave paintings of Ajanta where one sees magnificently naturalistic plant forms painted in the small square compartments of the ceilings.

The flowering sprays spotted about on the ground seen in the *Hamza-nama* page 76, *Painting of India,* just mentioned are also seen in the Deccani examples reproduced on page 118 of the same book but the trees and decorative vegetation in both pages 76 and 118 may be traced to the Pala pages and to Ajanta. The relationship to the Deccan seems close and it appears certain, therefore, that artists were drawn from that region as they were from many other areas, Central Asia, Persia, perhaps even Nepal and Tibet. Along with the beauty of the plants and trees, rich elaborations of building decoration are everywhere, with great varieties of geometrized tile ornament on floors and walls, along with bands of floral scrolliation decorating the architecture as well as the floors, where they may represent rugs.

But in returning to the quality and character of the draftsmanship, one must refer to the sixty pages in Vienna where one sees magnificently expressive figural painting, at times impressionistically vivid, and always with a rhythmic line. Also, one must not overlook what appears to be true portraiture already in the *Hamza-nama.* In looking at our Pl. 139, the seated jailkeeper in white, who is being handed a key by an individual in a red coat, could hardly be more expressive. The intensity one sees in the heavy jowled face, the character expressed by the gesture of his small hand, create for us a personality. His obese body shown under the transparent white of his garment is handled with much delicacy, both in line and modeling, already announcing the great school of Mughal portraitures.

Most expressive linear draftsmanship and fine portraiture in *Hamza-nama* already in existence.

Pl. 139 Zardhank Khatni brings the key to the prisonkeeper. From a *Hamza-nama* manuscript, Mughal, ca. 1562-77, size 26$^7/_{16}$″ by 20$^1/_8$″, Freer Gallery of Art, Smithsonian Institution, Washington, D.C. (49.18)

Pl. 140 A warrior at the fortress gate. From a *Hamza-nama* manuscript, Mughal, ca. 1562-77, size 28$^1/_8$″ by 21¾″, Seattle Art Museum, Richard Fuller Collection.

In summation, the *Hamza-nama* pages present us with a distinct and recognizable style, causing them to be always identifiable, not only because of their size but because of the style of their entire painting, the beauty of which can

known to have been put in charge of the atelier when it was first brought to New Delhi. I quote from page 43 of *Imperial Mughal Painting* by Stuart Cary Welch who tells us that Abd-as-Samad, the second director of the project, had been a somewhat conventional artist prior to the time when, according to Abu'l Fazl, "He was stirred to new heights by the alchemy of Akbar's vision, and he turned from outer form to inner meaning." Apparently Akbar's contemporaries were aware of the enormous influence young Akbar exercised on his atelier in the preparation of this first great work.

The style of the drawing has at times been referred to as coarse, but it might instead be considered that the line on the other hand possesses much vigor and speed, often impressionistic in its aim and effect. One has only to point to page 140 in *Persian Painting* by Basil Gray, Skira, 1977, to a painting by Mir Musavvir, to observe the enormous difference to the many figures in the *Hamza-nama* pages, many of which must be by this same master. A magnificent example of this great work is illustrated in Persian Painting, page 76, in *Painting of India*, by Barrett and Gray as well as on Pls. 139 to 141 of the present volume and in the sixty magnificent examples, now in Vienna, illustrated in full in *Die Indischen Miniaturen aus Haemsa Romanes,* Wien, 1925, by H. Gluck.

The extremely realistic, even impressionistically suggestive, character of many of the figures in the *Hamza-nama,* although always expressed in a continuing line, is to be seen in a most unusual Persian painting, if indeed it be by a Persian artist, as Schroeder suggested its Mughal authorship. This painting, although of a slightly later date, ca. 1590, is to be seen on page 157 of *Persian Painting* by Basil Gray, attributed to Muhammadi. Here the lively and vivid actuality of all these drinking dervishes, rendered in an expressive line with delicate subtle modeling, seems to relate quite closely to the *Hamza-nama* pages. The presence of European influence in fifteenth-sixteenth century Persia cannot be ruled out, as European artists are known to have visited there, perhaps accounting for the increased realism, especially of the portrait-like faces, already to be seen in Bihzad and because of contacts between Tabriz and Venice in the fifteenth century. Bellini was thought, but now doubted, to have visited Persia.

European influence already in Persia by the fifteenth century.

If one studies closely black and white reproductions of the pages in Vienna, one will see a great variety of influences including European, probably already introduced by the copper engravings brought to Akbar's court by the priests from Goa. Pl. 48 shows us what appears to be a praying Christian priest in the upper left hand corner standing on a mountain, with again suggestions of European influence in the heavily modeled fluttering draperies particularly noticeable in Pl.9, again of the Vienna series. However, these slight suggestions of European presence have in no way affected the style of the *Hamza-nama,* which remains mainly flat and linear in spite of whatever modeling may exist. Later on European influence will inspire the Mughal artist to attempt atmospheric tonality, which will shortly become the aim and objective of Akbar's atelier and all Mughal painting through the seventeenth century, but it will never abandon the firmly defined line which will encase all its forms, however modeled, even with directional lightning.

Modeling exits but without attempt at light and shade.

Several large typically Chinese dragons will also appear in these pages in Vienna along with great gnarled tree trunks, scrolling clouds, as well as tossed-about crags, a characteristic of sixteenth century Persia, although ultimately derived from China. The fantastic tossed-about water, filled with fish, tortoises, and suggested fantastic creatures must be due to the local exuberance of the atelier under Akbar's guidance (we must not forget that he was an artist himself).

Chinese influence in clouds, rocks and water.

Not all of the figures in these compositions will be equally well painted by any manner or means. Some of the minor personages will revert to the rather formalized faces and figures seen in late fifteenth, early sixteenth century rather routine Persian painting, but the life and vitality of the vast majority of these pages is such that a discrepancy in the draftsmanship of a figure here or there seems hardly to interrupt the flow of the action, so that, although several or many hands may have collaborated on these pages, the results are often more alive and successful than

Uneven quality of draftsmanship does not prevent the great flow of action.

abound in closely observed studies of flowers, animals, and birds, which latter are among the finest of their kind known. The paintings produced in his workshop also possess a far greater intimacy and informality than either the paintings of his father Akbar, who commissioned such enormous numbers of epic manuscripts, or his son Shah Jahan whose taste will run in the direction of formal imperial portraits of a more impersonal character.

After becoming emperor, Jahangir will fall under the influence of another powerful personality, the wife of one of his father's Persian grandees whom he had seen in his father's harem as a very young man, and whom he married after the death of her husband, naming her Nur Jahan (Light of the World).

Jahangir falls under the influence of Nur Jahan, his wife, who attempts to save him from alcoholism.

Remarkably cultivated and intelligent, Nur Jahan shared Jahangir's intellectual and artistic interests, but as time passed, the dissipation from alcohol and opium to which Jahangir's Turkish and Mongol ancestors were prone, so reduced his powers of both mind and body that he even turned over affairs of state to the competent and willing hands of his wife. Nur Jahan was devotion itself and in every way attempted to reduce the drinking habits of her husband. A tiny cup carved from a solid emerald which John Gallatly purchased from Nasli Heeramaneck in the Thirties, and subsequently donated to the Smithsonian Institute in Washington, D.C., was given by Nur Jahan to Jahangir in the hope of reducing his drinking habit. However, due to the resentment brought about by the power of her family at court, after Jahangir's death Nur Jahan sank into obscurity.

Nur Jahan's niece, originally named Arjumand Banu Begam, will marry Jahangir's son, Prince Khurram, the future Shah Jahan, who named her Mumtaz Mahal and, after her death at the birth of her fourteenth child, he will immortalize her by building for her the great tomb now known as the famous Taj Mahal.

Taj Mahal immortalizes Mumtaz Mahal.

Prince Khurram ascended the throne after the death of Jahangir as Shah Jahan, ruling from 1627 to 1657, when he was deposed by his own son, Aurangzeb. Although his son will accuse him as the years pass of having grown out of touch with the day-to-day problems of imperial government, he was actually not such a poor administrator and, in spite of his sensuous weak character and excessive cruelty to competing members of his family, nevertheless was one of India's greatest emperors, bringing magnificence and glory to Delhi and Agra, leaving the memory of the period of Shah Jahan as a shining moment in India's history.

Sumptuous and lavish style of Shah Jahan.

Shah Jahan's son, Aurangzeb, blaming his father for incompetence, imprisoned him in Agra Fort, proclaiming himself emperor in 1657. Shah Jahan, already an old man, still lived until 1666. His confinement, however, did not deprive him of luxurious surroundings and above all his beloved womenfolk. Aurangzeb, a rather austere individual of ascetic taste, lacked the love of painting of his three famous predecessors, and it is from his reign that the decline of the great school of Mughal painting sets in. Much fine painting will still take place, but it is from this period that artists will begin to seek patronage farther afield, to Rajput courts and into the Punjab Hills. Here under wealthy rajas a beautiful school of Hill painting comes into being and the fine school of Mughal painting is close to an end.

We will now turn to the *Hamza-rama,* the first monumental achievement of Akbar's atelier in India.

The style of the *Hamza-nama,* which may also be seen in a few other small works, notably in the *Tuti-nama* in the Cleveland Museum of Art which has been reproduced in toto in a large publication of Promod Chandra, which may pre-date the *Hamza-nama,* is not to be thought of merely as an early stage in the Mughal School, but to be regarded as a great style in its own right, the first in a school that contained more than one manner of painting, although they were more or less contemporaneous.

Discussion of the *Hamza-nama,* first great Mughal style.

Undoubtedly influenced by the size of the pages, the style nevertheless possesses a boldness and large scale drama not present in paintings executed in Persia by some of the very artists who are known to have collaborated on many of these pages, such as Mir Musavvir, Mir Sayyid Ali as well as Abd-al-Samad, who is

in Pl. 203 also emerges from a dark background, but all the forms of his face are clearly and subtly defined, whereas in this example of *sfumato* modeling, the face rises into the light out of the shadowy areas of eyes, nose and mouth. Here one is describing form by pulling it out of shadow as opposed to using shadow or modeling only where necessary to describe a contour that cannot suffice through line alone. It is interesting to observe that the figure of a torchbearer top right, in Pl. 203 next to the Titian-looking individual, although painted in the same Mughal style of subtle surface modeling as the other individuals in the painting, is perhaps the most convincing and successful painting in the entire picture, perhaps because, not being one of the great ministers but only a torchbearer, he was painted by the same hand who executed the body of the painting, and is therefore more united to the tonality of the background.

Pl. 204 is an expressive example of Jahangir shooting an arrow into the eye of a skeletal white-haired, white-bearded black individual, intended to represent Poverty, as he stands on a globe containing a representation of a lion lying with a lamb and belonging to the first half of the seventeenth century. The small winged putti, one handing him arrows and the others holding his crown in the sky, are of course Europe-derived as are the clouds. However, the face of the emperor possesses great character, as does his entire attitude, expressed in the firm outline of his coat, although various parts of this painting may be by different hands, which is suggested by the trousers and feet that appear below the coat. There are a number of versions in existence of this subject although not exactly similar to this. The modeling of the face of the emperor is very close to the modeling of many of the faces in the painting in Pl. 203, however, the face of Jahangir himself always appears slightly different in almost every portrait that exists of him. (See our two paintings, Pls. 204 and 214 as well as our small portrait drawing Pl. 165 with the enlargement, which Milo Beach has dated ca. 1620 as he has dated the example in Freer to 1615-1616. One must realize that four years in the life of a man as dissipated as Jahangir could bring about this extreme alteration of physiognomy.) The painting has been inserted into a gold floral painted border probably of the same period, 1620-1630, but perhaps painted in Persia, which was a usual practice both at the time the album was put together as well as in many subsequent cases.

On Pl. 205, centering a border of flowering plants, is an extremely delicate, jewel-like painting of two standing lovers, which, for all the passion suggested by the painting as they hold each other in an embrace while he presses her foot, are nevertheless each staring into space with no true sense of passion conveyed, although it may be said that a steady feeling of conjugal felicity may be expressed. But if we look to Pl. 209 we will see quite a different story. Here the sultry lady reclining in the arms of her lover glances into his eyes with a look of unfathomable depth, while her lover, drinking her toast, looks down at her with sensuous tenderness. There is perhaps no other painting in the entire repertoire of Mughal love scenes that expresses romantic passion with such emotional feeling. Both paintings possess the same exquisite delicacy of execution and are attributed by Cary Welch, who illustrates them both in *The Art of Mughal India,* Asia House, 1963, to Govardhan. On Pl. 205, the light airy tonality and jewel-like colours might place the painting slightly earlier than the example Pl. 209 yet the modeling of the face of the prince exhibits something of the *sfumato* attempt inspired by European copper engravings such as we see in the enlargement on Pl. 189 and the small willow tree and sky are characteristic of the Jahangir period, although the painting may come closer to 1620-1630.

It has been thought that the lovers in Pl. 205 represent Jahangir with his most adored wife, Nur Jahan, but if one notices the individual standing offering a sweetmeat to Jahangir, in Pl. 206, one will see a strong resemblance to the so-considered figure of Jahangir in Pl. 205, perhaps signifying that the individual in Pl. 206 holding the dish was a stand-in for the emperor in the painting Pl. 205, as it might have been thought unseemly for the emperor to be represented with such intimacy.

Pl. 204 The Emperor Jahangir on a Globe Shooting Poverty, by Abu'l Hasan, Mughal, early 17th century, size $14^1/_2$" by $9^3/_4$", Los Angeles County Museum of Art.

Pl. 205 Lovers, by Govardhan, 1615-1620, size $7^3/_8$" × $4^9/_{16}$", Mughal, Los Angeles County Museum of Art.

Pl. 209 compared with Pl. 205.

Pl. 205 and 209 discussed.

Pl. 206 Jahangir with a courtier and attendant, Mughal, early 17th century, size $10^{15}/_{16}$" by $11^1/_4$", National Gallery of Canada, Ottawa. (23.558)

Speculating a bit further, one could notice that the young lady in green pants holding a dish to the left of our lovers Pl. 205, bears a certain resemblance to the passionate reclining lady Pl. 209. Shah Jahan, as Prince Khurram, married Nur Jahan's niece Arjumand Begam in 1612, one year after Jahangir had married Nur Jahan, so that the passionate lovers could represent Prince Khurram and his adored wife whom he named Mumtaz Mahal and for whom he built the Taj Mahal after she died at the birth of their fourteenth child. This may very well have been painted before Shah Jahan became emperor, in 1627. But it is more than probable that Govardhan was representing Nur Jahan and Jahangir, perhaps painted as a memorial to the first love of their youth at the end of Jahangir's life.

Pl. 209 again discussed.

On Pl. 207 we see another rendering of Jahangir. He is seated in a gold chair under a red canopy with his minister in a light and airy colour scheme characteristic of early Jahangir painting. The emperor is still a young man, whereas in Pl. 206 he is already middle-aged.

Pl. 207 Jahangir with a minister and attendant, Mughal, early 17th century, reduced by half, Private Collection.

On Pl. 208, in a beautiful floral border, is represented a charming most romantic painting of Majnun, emaciated for love of Laila, sitting on rocks in the wilderness, dressed in a leafy skirt and playing with a fox under a delicate willow tree while a bird perches on his head. The romantic lyricism of the painting relates it to the lovers Pl. 209 also dating to 1630.

Pl. 208 Majnun, Mughal, ca. 1630, just under life size, New York Private Collection.

Pl. 209 Lovers on a Terrace, by Govardhan, ca. 1630, size $6^{1}/_{4}$" by $4^{5}/_{8}$", New York Private Collection.

On Pl. 210 we see a fine example of the beautiful border elaborations with paintings of animals, birds, and flowers that decorate calligraphy under Shah Jahan.

Pl. 210 Pages from an Album of Shah Jahan, Mughal, ca. 1650, $14^{5}/_{8}$" × 10", National Gallery of Canada, Ottawa. (23.556)

Pl. 211 is a scene of four mullahs (wise men) seated in a landscape, attributed to Govardhan, ca. 1630, belonging to the early period of Shah Jahan. We have here one of the closest approximations to a European scene, as the background appears to have been completely copied from a Flemish painting, with sky modeled to emulate the soft cloud effects of northern painting. But the seated figures which blend most beautifully into the tonality of the painting are not atmospheric in their handling, instead all the faces and bodies retain the linear delicacy and subtle modeling of fine Mughal painting, such as one also sees in early Italian tempera painting.

Pl. 211 Four Mullahs, attributed to Govardhan, Mughal, ca. 1630, size $8^{1}/_{8}$" by $5^{1}/_{4}$", Los Angeles County Museum of Art.

Pls. 212 and 213 show us two portraits from an Imperial album belonging to the period of Shah Jahan. On Pl. 212, the profiled figure of the Emperor Shah Jahan stands holding a jewel, green halo bordered with gold flames behind his head against a pale turquoise sky rising to a gold and orange sunset, with delicate flowering plants at his feet. This painting is typical of the sumptuous imperial portraits produced in his reign, lacking in intimate character study, as they favour a more formal presentation. This painting is probably one of the numerous copies of this same subject produced in his ateliers.

Pl. 212 Shah Jahan Holding a Jewel, from the Late Shah Jahan Album, Mughal, ca. 1645, size $14^{3}/_{8}$" by $9^{3}/_{4}$", Los Angeles County Museum of Art.

However, the painting on Pl. 213 is a portrait of a non-imperial individual painted with the greatest degree of life and expression. From the sharp and alert rather jowled little face with mustache, to his swelling body under his beautifully striped coat, which spreads the material tight at his shoulders and arms, to his expressive rather chubby hands, the character in this portrait is so pronounced and alive that one would feel that the individual stood for it, whereas the portrait of Shah Jahan appears to have been produced from an original that was probably assembled from different studies, as it lacks unity in all its parts, as is often the case with a painting assembled from different studies. There are some finely painted portraits of warriors, ministers and attendants in both the borders of Pl. 212 and 213 although even some of these appear as though they might be by more than one hand, whereas others are better realized as complete figural units, but the faces throughout represent exceptionally fine portraiture. Evidence that some of these figures may be copied from other paintings shows in the seated figure in striped coat, holding a shield with one raised knee, in the upper left border of Pl. 213, where one can see that the hand is facing the wrong way.

Pl. 213 Portrait of a Rajput, from the Late Shah Jahan Album, Mughal, ca. 1645, size $15^{1}/_{8}$" by $10^{3}/_{4}$", Los Angeles County Museum of Art.

On Pl. 214, much reduced in size, we see a remarkably characterful portrait of the Emperor Jahangir in his middle years, with an enlargement of this on Pl. 215. Although this must be a copy, painted in the period of Shah Jahan, it nevertheless is an exceptionally fine likeness, with intense life and character. The extremely expressive and delicate painting of the eyebrows and eyes, the mouth, the subtle modeling of his slightly sagging neck and ear, the delicacy of the turban, the quality of the line and modeling throughout, show us the remarkable talent of the Mughal painters. It was probably taken from a very close representative drawing of the period itself, such as our examples reproduced 175-178 which the artist may have developed into his own colour elaboration. Our enlarged drawing of Jahangir's head Pl. 165, shows the emperor as an older man and could not have served as the original sketch for this portrait, but the superb quality of the Mughal artists' drawings may be seen in our examples reproduced on Pls. 175 through 178.

Pl. 216 gives us one of the few imperial portraits of a Princess, or possibly even a lady of the harem, standing profile holding a flower in transparent gauze-like garment revealing nude the upper portion of her body, with trousers of richest gold brocade with brocaded red shoes and sash. She stands against a turquoise background with beautiful flowering bushes, the painting framed by a double border with gold painted flowers against coral background, and the large outer border filled with beautifully gold outlined flowering bushes. Undoubtedly also a page from an imperial album of Shah Jahan's period, it is a fine and rare example, but extremely formal (now in the Virginia Museum of Art).

On Pl. 217 we have portraiture of the period of Shah Jahan at its best. Shah Jahan sits enthroned with green halo surrounded by his two sons and a chauribearer, each painted with extraordinary character and superb draftsmanship. The colour is jewel-like, a black floral scrolling rug of European design, bordered with pink flowers, is underfoot and a toned pale turquoise sky ends in great streamers of sunset clouds. The painting is bordered by exquisite flying birds, ducks and flowering plants.

In Pl. 218 we again see a magnificent example of elaborately decorated calligraphy, with several inner borders, with one wide border of the finest, most delicate linear trailings filled with flowers and sensitively painted ibex, deer and birds.

Pl. 219 is a night scene of the late Shah Jahan period. Although the dark mountain and night sky with strip of moon are painted in a deep rich tonality, with perhaps considerable borrowings from a European painting, especially in the cloud-filled sky, the figures themselves as they sit, kneel and stand around a small wood fire appear rather flat and cut-out. The modeling of their forms shows a weakness in draftsmanship which suggests the end of great Mughal painting and we now approach the period of Aurangzeb.

On Pl. 220, in strong contrast to the night scene Pl. 219, is seen one of the finest double portraits in the entire book representing two superbly painted portraits of rulers enthroned together in a blaze of light while European-inspired putti hold a small canopy above in the lightly suggested clouds. Cary Welch, in *The Art of Mughal India* (Asia House) informs us that this double portrait which he reproduces page 44 represents Shah Shuja, seated on the right, and Raja Gaj Singh of Marwar, who are commemorating their services together in the Deccan. In this magnificently painted portrait which has been attributed to Bichitr and is in Los Angeles, dated 1638, modeling, line, colour and character could hardly be surpassed. The figure of the seated Raja, at left, with almost invisibly subtle modeling, is as completely solid and round as an early Italian portrait, and the firm line which reveals outline of face and body in these individuals is expressive to a degree. These two paintings could not be in greater contrast, the rather weak and feeble drawing in 219 suggesting that it might have been executed already under the reign of Aurangzeb, although the charm and mood of the painting are presented with true poetic delicacy.

On Pls. 221 and 222, we are entering the later Mughal school. The extremely charming and spontaneous drawing of a young princess holding a flower, Pl. 222, is most certainly from the Deccan, late seventeenth century, as may be the young prince in Pl. 221. Although this portrait, Pl. 221, lacks the firm contours of the earlier portraits shown in this book such as the examples on Pls. 183, 184, 185 and 196, it still has a freshness of vision. The face is subtly modeled and plastic, but the body lacks the firm solidity shown in earlier Mughal painting, as the white gold-brocaded coat has a slightly careless lack of strong design, and was probably executed at the turn of the century, perhaps by a fine Mughal artist working for a non-imperial patron.

On Pl. 223, however, in the painting of a white and red horse with groom, precise line and modeling seen in the figure of the groom has become, by about 1720, comparatively hard and stiff when compared with the seventeenth century. The charming small painting of a princess, arms akimbo, on Pl. 224 is a far more informal and spontaneous presentation when compared to the formality of the princess on Pl. 169, but less effort is given to both line and modeling and we have here an approach to the charm of Rajput painting.

The standing prince Pl. 225, probably representing Maharaja Gaj Singh of Bikaner, whom we will see again on Pl. 248, is a stunning example of the degree to which the Mughal style, retaining some of its character, modeling and expressiveness, takes on a decorative element of stylization in Rajasthan. The obese Maharaja's fleshy face is modeled with great character, but his elegant mustache, sidesburn and turban are decorative and elegant in the extreme, as is the rest of this remarkable figure, from his dark olive brocaded coat, bulging open to reveal rich jeweled pendants, to his gold brocaded sash, red brocaded straight legs encased in stiff white gauze skirt, and arm and hand covered with jewels as he holds his sword.

On Pl. 226, in a most lively and humorous scene, a very naughty mischievous-looking elephant is scaring to death a rearing horse whose head expresses complete consternation and fear. His rider turns and stabs the elephant's trunk while the elephant's rider prepares to whack him one with his elegant biforked instrument which Mahuts carry for this purpose. This painting, although possessing many Mughal traits, has the impressionistic freedom and spontaneity of the Rajput school, and, according to Anand Krishna, was painted at Kotah in Rajasthan around 1760, which school we have already spoken of in the section on Rajput painting.

The two paintings, Pls. 227 and 228 belong to a very early provincial Mughal school perhaps at Bundi. The girl holding garlands in a forest, with monkeys dashing through the trees, peacocks below, is in an early style, with pre-Mughal characteristics in the face of the girl as well as in the trees with their stiffer tree trunks. In the example below right, Pl. 228, Mughal architecture is not yet very developed, and the standing and seated figures exhibit certain pre-Mughal characteristics, to be dated ca. 1630.

The painting on Pl. 229 represents the music-maker Krishna dancing in the rain with his female companions who join him with great gusto, one with drum the other with castanets while peacocks watch the scene in the trees above. This painting has the lively charm of the provincial Mughal school, and was probably executed at some minor Rajput court in the mid-seventeenth century, probably at Bundelkhand.

On Pl. 230 is a painting which is very early seventeenth century Mughal in draftsmanship, showing a mischievous elephant attempting to uproot a decoratively leafy tree. It may be from the Deccan, or might also be a later copy from an earlier Mughal original. Pl. 231, a drawing more truly Deccani in style, shows a prince with flowing garments attempting to hold his stamping steed. The line is more calligraphic than naturalistically expressive, and, although with an attempt at modeling, it appears to owe much to Persia. This tinted drawing may be early seventeenth century from the Deccan.

Pl. 221 A Courtier, Mughal, late 17th or early 18th century, size 9½" by 5¹⁵/₁₆", National Gallery of Canada, Ottawa. (23.569)

Pl. 222 A Lady Holding Flowers, Mughal, late 17th century from the Deccan, slightly enlarged, New York Private Collection.

Pl. 223 Horse and Groom, Mughal, 2nd quarter of the 18th century, Kishangarh style, size 10¼" by 14", National Gallery of Canada, Ottawa. (23.95)

Pl. 224 A dancing Princess, Deccan, early 18th century, Approximate size, Private Collection.

Pl. 225 A Courtier, Jaipur 1760, set in a floral page, size 16" by 14", Private Collection.

Pl. 226 A Rampaging Elephant, Ajmer or Kotah, ca. 1760, size 11¼" by 8¾", Los Angeles County Museum of Art. (M.77.19.18)

Pl. 227 From a *Ragamala* series, early Rajput possible Bundi, ca. 1610, Approximate size, Private Collection.

Pl. 228 From a *Ragamala* series, early Rajasthan, possibly Bundi, ca. 1630, Approximate size, Private Collection.

Pl. 229 The Rain Maker, from a *Ragamala* series, from Bundelkhana or Bundi, ca. 1610, 6" x 8", Virginia Museum of Art, Richmond, Virginia. (68.8.61)

Pl. 230 An Enraged Elephant, from the Deccan, ca. 1720, Approximate size, Private Collection.

Pl. 231 Horse and Groom, Deccani, early 17th century, twice enlarged, Private Collection.

Pl. 140

Pl. 139

Pl. 141

173

Pl. 142

174

خزری بود از مردی که او را سلام ابرش کشندی و طباخ بی‌نظیر بود بنابرین معتصم او را از سلام ابرش خرید
وچون شجاعت و جلادت و تندی او را مورد داشت معتصم او را بمرتبه امارت رسانید و بعد از وی زرین
واثق بن معتصم مرتبه او را بسیار بلند شد و در زمان متوکل ولایت حرمین و حجاز باو تعلق داشت القصه
چون در میانه الباخ و متوکل درستی آن صحبت واقع شده که وجه متوکل ظاهر ملائی آن نمود اما در باطن
از وی کینه داشت و این معنی را الباخ فهمیده بود بنابرین جماعتی در میان انداخته رخصت حج طلبید
و متوکل او را رخصت حج کرد و گفت الباخ در قلمرو من در هر شهری که باشد امارت آن شهر متعلق باو
القصه الباخ متوجه حج کرد و متوکل ولایت حرمین و حجاز را بوصیف ترک متعاقب رسید الباخ بالفوره
بعد از او حج بجانب سامره مراجعت نمود و چون

الباخ در حین مراجعت از حج بینداد و رسید اسحق بن ابراهیم که والی بغداد
بود او را باد و پرسش منظور و پسرش منصور و منظم و دو روز پرسش سلیمان بن وهب و قدامة بن زیاد النصرانی گرفت ملازم
در تخت عقوبت مسلمان شد و از عقوبت خلاص کشت اما الباخ را از طعام منع کردند و بعد از چند روز
که گرسنگی او بنهایت انجا میده طعام بسیار بوی دادند و بعد از طعام مر چند آب طلبید نیافت تا آنکه از تشنگی
بمرد و پسرانش در بند می بودند تا زمان خلافت مستعین متوکل رسید و او را از بند بیرون کرد
و در ماه شوال این سال بغا محمد بن شعیب را و برادرش صفو و خاله را با دو از یکان بسامره آورد و متوکل فرمود تا همه ایشان را بر شتران سوار
کرده بشهر در آرند تا موجب عبرت خلایق شوند و چون محمد شعیب را پیش متوکل حاضر کردند او از وی بپرسید
که چرا بر چنین امر شنیع اقدام نمودی باعث چه بود گفت یا امیرالمؤمنین بر گنجی ذاتی و اعتماد بر عفو
امیرالمؤمنین پس متوکل بسخن او را بیت الثقات و الفقات ناکرده جلاد را اشاره کرد که او را با متا بعاشنش بزند در
محل محمد علی البد بیهمینی چند در حسب حال خود و ملح متوکل افشا نمود متوکل چون آن را با سیاستی
شنیده گفت با این مرد دبی تمام است بس از کشتن او در گذشت و درک میکوند که معترض متوکل شفاعت
او بر ناجی بر مر نقد یزو او را در زندان کردند و بعد از مدتی از بند برکیت و از جمله وقایع این سال آنکه متوکل
در بغای و قلمرو خود حکم فرمود که با هل ذمه یعنی نصاری و یهود و مجوس زن و مرد ایشان در لباس مثلا زر
بپوشند بنا برین از مسلمانان از لباس عملی ایشان قرار داد و حکم فرمود که علما را ایشان باید که بر دوس
خود پاره در زنگ مخالف باشد بزرگ ایشان بروز ند و باید که جمع ایشان جادری را طرحین
زنار بر بالای جامه می پوشیده با باشد و بر اسب سوار ننشوند بلکه مرکوب ایشان باید آن از چوب
باشد و مانده بهل و حکم کرد که ایشان را طلقا آن امور دیوانی را بوا سطه آن حکم بسلمانان میکرده
باشد و فضل بند و کلیس مستجد خذ ایشان را خراب کرده بجای آنها مسجد سازند و منازل
فراخ ایشان را تنگ سازند و بابقی را مساجد بنا کنند و قبرهای ایشان را با زمین برابر کنند

Pl. 143

Pl. 144

176

Pl. 145

177

Pl. 147

Pl. 148

Pl. 149

Pl. 150

Pl. 151

Pl. 152

Pl. 153

Pl. 154

Pl. 155

187

Pl. 156

Pl. 157

189

Pl. 158

Pl. 159

Pl. 160

Pl. 161

193

بر مخالفت اختیار کرده و ظاهراً دعوی دوستی و یکانگی می کنند و ... احوال آنحضرت و بهزادیان پدر ... اسلام ... ملکه می فرستند

حکایت جلوس تقی دامغانی و ... بادشاه بیشان ... ایشان ... و بعد از ... ایشان را یک کشتن

Pl. 162

Pl. 163

195

Pl. 164

Pl. 165

Pl. 166

Pl. 167

Pl. 168

Pl. 169

Pl. 170

Pl. 171

Pl. 172

Pl. 173

Pl. 174

پیر بزرگ که جهانگیر باوه بش

Pl. 175

Pl. 176

Pl. 178

Pl. 177

Pl. 179

206

Pl. 180

Pl. 181

Pl. 182

نا بنہ این شکل در قلم او آورد

Pl. 183

Pl. 184

Pl. 185

209

Pl. 186

Pl. 187

Pl. 188

Pl. 189

Pl. 191

عمل وکار رب سکنات بود

Pl. 190

213

Pl. 192

Pl. 194

Pl. 193

Pl. 195

Pl. 196

Pl. 197

Pl. 198

Pl. 199

Pl. 200

Pl. 201

Pl. 202

223

Pl. 203

Pl. 204

Pl. 205

Pl. 207

Pl. 206

Pl. 208

Pl. 209

Pl. 210

Pl. 211

Pl. 212

Pl. 213

233

Pl. 214

Pl. 215

Pl. 216

Pl. 217

236

Pl. 218

237

Pl. 219

Pl. 220

Pl. 221

Pl. 222

Pl. 223

Pl. 224

Pl. 225

Pl. 226

Pl. 227

Pl. 228

Pl. 229

Pl. 230

Pl. 231

246

Pl. 232

Pl. 233

Pl. 234

Pl. 235

Pl. 236

Pl. 237

Pl. 238

Pl. 240

Pl. 239

251

Pl. 241

Pl. 242

Pl. 244

Pl. 243

253

Pl. 245

Pl. 247

Pl. 246

Pl. 248

Pl. 249

Pl. 250

Pl. 251

NOTES

[1] Bactarian or Gandharan influence would appear evident in the earliest style at Cave 2, which Dr. Sivaramamurti dates in the second century B.C. seen at Ajanta. But the rich earth colour probably descends from an earlier style more related to Mesopotamia with which India has her earliest trade in antiquity by boat. Ernst Herzfield already in 1941 illustrates two fresco fragments from Iran, probably Susa, one more classically related and the other more indigenous and related to frescoes which have since been found in Assyria. Other evidence of India's earlier commerce with Mesopotamia is seen in her first alphabet which developed in the south.

[2] A generic term implying a period, from the third through the seventh centuries, extending beyond the actual territory of Gupta hegemony. The most ancient painting of India was probably in the tawny earth colour palette of Mesopotamia and Susa with which India had her earliest trade relations.

[3] C. Sivaramamurti, *South Indian Painting,* National Museum, New Delhi, 1968.

[4] Moti Chandra, *The World of Courtesans,* Vikas Publishing, Delhi and London, 1973.

[5] Gordon Luce, *Old Burma—Early Pagan,* Artibus ASIAE, 1969-1970.

[6] Fragments of eighth century Manichean manuscripts on paper with painted illustrations were exhibited in the Metropolitan Museum of Art in the *Along the Ancient Silk Route* Exhibit New York, 1982.

[7] H. M. Elliot, *History of India as Told by its Own Historians,* New Edition New York 1966 pages 185-186. We quote a reply from General Hajjaj to his nephew, Muhammad Kasim, "The letter . . . has been received . . . it appears that the chief inhabitants . . . have petitioned . . . to repair the Temple of Budh (Buddha) and pursue their religion. As they have made submission and have agreed to pay taxes to the Khalifa, nothing more shall be properly required from them. They have been taken under our protection and we cannot in any way stretch out our hands upon their lives or property. Permission is given them to worship their gods. Nobody must be forbidden from following his own religion." However, other authors have pointed to great cruelty on the part of Hajjaj.

[8] Sir H. M. Elliot, *The History of India as Told by its Own Historians,* New York, A.M.S. Press 1966, p. 506. We read of an Arab writer's reference to various prerequisites of Muhammad Kassim as follows: ". . . the sculpturing or otherwise perpetuating the personal representations of their conquerors."

[9] This prohibition probably applied to the general public, including the Moslem nobles, but not necessarily the immediate court, as all of the Sultans, mainly of Turkish descent, were extremely heavy drinkers, as were later Moslem rulers.

[10] The early Arab geographers of the ninth—tenth centuries observed that several Hindi rulers were totally abstemious, not because of religious beliefs, but for fear that alcoholism could cloud their administrative abilities. This might be interpreted as a reaction to the profligacy of the Gupta Age which we read of in *The World of Courtesans,* very much to be compared with the debauchery of the last days of Rome.

BIBLIOGRAPHY

This bibliography follows the chapters of the book, except that the Rajput and Mughal are reversed.

ANCIENT AND CLASSICAL ART, by Kahane, P. P. Edited by Hans Jaffee, Translated by Robert Erich Wolf, Dell Publishing Co. (reprint of Abrams edition), 1968.

IRAN IN THE ANCIENT EAST, by Herzfeld, Ernst E., Oxford University Press, 1941.

AJANTA, parts 1-4, Yazandi, G., Oxford, 1929-1934.

THE WALL PAINTINGS OF INDIA, CENTRAL ASIA, AND CEYLON, by Rowland, B. Boston, 1938.

AJANTA, by Singh, Madanjeet. Ajanta Painting of the Sacred and the Secular, The Macmillan Co., 1965.

"WESTERN CHALUKIAN PAINTINGS AT BADAMI," by Sivaramamurti, C., LALIT KALA AKADEMI, 5 April 1959.

ARAB PAINTING, By Ettinghausen, Richard. Treasures of Asia (Skira) 1977.

CENTRAL ASIAN PAINTING FROM AFGHANISTAN TO SINKIANG, by Bussagli, Mario., Treasures of Asia (Skira) 1979.

ALONG THE ANCIENT SILK ROUTES, Catalogue of an exhibition held at the Metropolitan Museum of Art, 1982. Central Asian Art from the West Berlin State Museum.

L'AFGHANISTAN ET SON ART, by Auboyer, Jeannine. Artia, Prague, 1968.

OLD BURMA, EARLY PAGAN, an Arbitus Asiae publication, by Luce, Gordon. 1970.

ANCIENT ARTS OF CENTRAL ASIA, by Rice, Tamara Talbot., Praeger, Frederick A. 1965.

"CAVE TEMPLE AND PAINTINGS OF SITTANNAVISAL," by Ramachandran, T. N., LALIT KALA AKADEMI, No. 9 April, 1961.

THE WORLD OF COURTESANS, by Chandra, Moti, Vikas Publishing House, 1973.

THE BAGH CAVES, by Marshall, Sir John and others, 1927.

THE ART OF INDIA, by Sivaramamurti, C. Harry Abrams, New York, 1974.

HIMALAYAN ART, Singh, Madanjeet., Unesco Art Books, 1968.

THE CULTURAL HERITAGE OF LADAKH by David L. Snellgrove and Tadeusz Skorupski.

BABUR NAMA (MEMOIRS OF BABUR), Translated from the original Turki text by Beverage, Annette Susannah.

THE EMBASSY OF SIR THOMAS ROE TO INDIA as narrated in his journal and correspondence, edited by Foster, Sir William, C.I.E. Oxford University Press, London, Humphrey Milford, 1926.

VOYAGES AND TRAVELS, by Kerr, Robert, F.R.S. and F.A.S. Edinburgh, 1813.

EARLY TRAVELS IN INDIA 1583-1619, edited by Foster, Sir William, C.I.E. Humphrey Milford, Oxford University Press, 1921.

HISTORY OF THE RISE OF THE MAHOMEDAN POWER IN INDIA TILL THE YEAR A.D. 1612, translated from the original Persian of Mahomed Kasim Ferischta by Briggs, John, M.R.A.S. Humphrey Milford, Oxford Univeristy Press, 1922.

THE HISTORY OF INDIA AS TOLD BY ITS OWN HISTORIANS, edited by Elliot, H. M. and Dowson, John, 8 volumes, 1867-77.

TRAVELS IN INDIA, Translated by Grey, E. 2 volumes, London, 1892.

AKBAR AND THE JESUITS, Translated by Payne, C. H., London, 1926.

THE COMMENTARY OF FATHER MONSERRATE, S.J., On his journey to the court of Akbar. Humphrey Milford, Oxford University Press, 1922.

MUSULMAN PAINTING, by Blochet, E. Translated from the French by Binyon, C. First published 1929.

SOUTH INDIAN PAINTING, by Sivaramamurti, C. New Dehli, 1968.

PERSIAN PAINTING by Gray, Basil. Treasures of Asia (Skira), 1961.

A KING'S BOOK OF KINGS, by Welch, Stuart Cary. The Metropolitan Museum of Art, 1972.

IMPERIAL MUGHAL PAINTING, by Welch, Stuart Cary. George Braziller, New York, 1978.

THE ART OF MUGHAL INDIA, Painting and Precious Objects, by Welch, Stuart Cary. The Asia society, Harry N. Abrams, Inc. 1963.

TREASURES OF INDIAN MINIATURES, by Gray, Basil. Bruno Cassierer, Oxford, 1955.

EARLY MUGHAL PAINTING, by Krishna, Anand., Lalit Kala Akademi, portfolio no. 10, 1978.

INDIAN MINIATURE PAINTING, by Dimand, Maurice. The Uffici Series in Full Colour, no date.

IMPERIAL MUGHAL PAINTING, by Welch, S. C. George Braziller, New York, 1978.

MUGHAL PAINTING, by Wilkinson, J. V. S., The Pitman Gallery of Oriental Art, 1949.

MUGHAL MINIATURES, by Krishnadasa, Rai, Founder-Curator of Bharat Kala Bhavan, Benares, Introduction by Humayun Kabir. Lalit Kala Akademi, 1955.

THE GRAND MOGUL, Imperial Painting in India, by Beach, Milo Cleveland, with a personal view by Welch, Stuart Cary. Fogg Art Museum, Harvard University, 1979.

MINIATURES FROM THE EAST, by Hajek, Lubor, Spring Books, London, 1960.

MOGHOL MINIATURES OF THE EARLIER PERIODS, Bodelian Library, Oxford, 1953.

A CATALOGUE OF INDIAN MINIATURES FROM THE LIBRARY OF A. CHESTER BEATTY, three volumes, by Arnold, T. W. and Wilkinson, J.V.S. Oxford, 1936.

LES MINIATURES INDIENNES DE L'EPOQUE DES GRANDS MOGHOLS DU MUSEE DU LOVRE, by Stchoukine, I. Paris, 1929.

LES PEINTURES ORIENTALES DE LA COLLECTION POZZI, by Blochet, E. Paris, 1928.

THE ART OF INDIA AND PAKISTAN, an exhibition held at the Royal Academy of Arts, London, 1947-48. Catalogue edited by Ashton, Sir Lee. Chapter on Indian Painting by Gray, Basil. London, 1950.

INDIAN MINIATURES FROM THE FIFTEENTH TO THE NINETEENTH CENTURY, by Skelton, Robert. Venice, 1961.

"WESTERN INDIAN PAINTINGS IN THE SIXTEENTH CENTURY," by Gray, Basil. Burlington Magazine, February, 1948.

JAIN MINIATURE PAINTINGS FROM WESTERN INDIA, by Chandra, Moti, Ahmadabad, 1949.

THE COURT PAINTERS OF THE GRAND MOGULS, by Binyon, L. and Arnold, T. W. Oxford, 1921.

INDISCHE BUCHMALEREIEN AUD DEM JAHANGIRALBUM DER STAATSBIBLIOTEK ZU BERLIN, by Goetz, H. and Kuhnel, E. Berlin, 1924.

DIE INDISCHEN MINIATUREN AUS HAEMSAROMANES, by Cluck, H., Vienna, 1925. (with 60 large page illustrations of the Hamzah Nammah in Vienna)

STUDIES IN INDIAN PAINTING by Mehta, N. C. Bombay, 1926.

A SURVEY OF PAINTING IN THE DECCAN, by Kramrisch, Stella. The India Society, London, 1937.

"AN ILLUSTRATED JAIN MANUSCRIPT FROM MANDAPADURG (MADU) DATED 1439, A.D.," by Khandalavala, Karl and Chandra, Moti. Lalit Kala Akademi, no. 6, October, 1959.

INDIAN PAINTINGS, SCULPTURE AND TEXTILES, by Coomaraswamy, Ananda. Howard University Gallery, Washington, D.C., May, 1948.

CATALOGUE OF THE INDIAN COLLECTIONS IN THE MUSEUM OF FINE ARTS, BOSTON, Part V: Rajput Painting, by Coomaraswamy, Ananda, Harvard University, 1926.

INDIAN DRAWINGS, by Coomaraswamy, Ananda London 1910-1912.

HISTORY OF INDIAN AND INDONESIAN ART, by Coomaraswamy, Ananda, E. Weyhe, New York, 1927.

RAJPUT PAINTING, by Coomaraswamy, Ananda. Humphrey Milford, London, 1916 2 vols.

INDIAN PAINTING, by Rawson, Philip, Universal Books, New York, 1961.

THE ARTS OF INDIA, edited by Gray, Basil. Phidon Press, 1981.

PAINTING OF INDIA, text by Barrett, Douglas and Gray, Basil. Treasures of Asia (Skira) 1963.

INDIAN MINIATURES, by Archer, W. G. New York Graphic Society, 1960.

THE LAUD RAGMALA MINIATURES: A study in Indian painting and music., by Stooke, Herbert J. and Khandalavala, Karl, Bruno Cassirer, Oxford, 1953.

"RAJPUT PAINTINGS FROM THE COLLECTION OF EDWIN BINNEY, III. AND W. G. ARCHER," by Binney, E. and Archer, W. G., Portland, 1968.

RAGMALA PAINTING, by Ebeling, M., Basel, 1973.

A FLOWER FROM EVERY MEADOW, by Welch, S. C., New York, 1973.

INDIAN DRAWINGS AND PAINTED SKETCHES, by Welch, S. C. New York, 1976.

GODS, THRONES, AND PEACOCKS, by Welch, S. C. and Beach, M. C., New York, 1965.

RAGMALA PAINTINGS IN THE MUSEUM OF FINE ARTS, BOSTON, text by Pal, P., The Museum of Fine Arts, 1967.

INDIAN PAINTING IN BUNDI AND KOTAH, by Archer, W. G., Victoria and Albert Museum, 1959.

THE LOVES OF KRISHNA, by Archer, W. C., London, 1957.

"MEWAR PAINTING IN THE SEVENTEENTH CENTURY," by Chandra, Moti, in Lalit Kala Akademi, Portfolio no. 9, no date.

"DECCANI PAINTING; THE SCHOOL OF BIJAPUR," by Gray, Basil, The Burlington Magazine, August, 1938.

PAHARI MINIATURE PAINTING, by Khandalavala, Karl, Bombay, 1958.

KANGRA PAINTINGS OF THE BAGAVATA PURANA, by Randhawa, M. S. New Delhi, 1960.

KANGRA PAINTINGS ON LOVE, by Randhawa, M. S., New Delhi, 1962.

BASOHLI PAINTING, by Randhawa, M. S., Printed in India, September, 1959.

RAJPUT PAINTING, Gangoly, O. C., Calcutta, 1926.

RAGAS AND RAGINIS, by Gangoly, O. C., Calcutta, 1934.

RAJPUT PAINTING, by Gray, Basil, London, 1948.

INDIAN PAINTING, by Archer, W. G. London, 1956.

TREASURES OF MINIATURES FROM THE BIKANER PALACE COLLECTION, by Gray, Basil, Paris, 1951.

PAINTING OF THE DECCAN, by Barrett, D. E., London, 1958.

CENTRAL INDIAN PAINTING, by Archer, W. G., London, 1958.

GARHWAL PAINTING, by Archer, W. G., London, 1954.

KANGRA PAINTING, by Archer, W. G., London, 1952.

KANGRA VALLEY PAINTING, by Randhawa, M. S., New Delhi, 1954.

MANIFESTATIONS OF SHIVA, by Kramrisch, Stella. Catalogue of the Philadelphia Museum of Art exhibition, 1981.

THE DELHI SULTANATE, THE BHARATIYAVIDYA BHAVAN'S HISTORY AND CULTURE OF THE INDIAN PEOPLE, vol. 6. Bombay, 1967.

THE MUGHAL EMPIRE, THE BHARATIYAVIDYA BHAVAN'S HISTORY AND CULTURE OF THE INDIAN PEOPLE, vol. 7, Bombay, 1974.

RAJPUT PAINTING AT BUNDI AND KOTAH, by Beach, M. C., Ascona, 1974.

VISIONS OF COURTLY INDIA, by Archer, W. G., Washington, 1976.

INDIAN PAINTING FROM THE PUNJAB HILLS, 2 vols. by Archer, W. G., London, 1973

THE ART AND ARCHITECTURE OF INDIA, by Rowland, Benjamin, Penguin Books, 1953.

THE KRISHNAMANDALA, by Spink, Walter.

USSIA

Miles
0 200 1000

R. Oxus

1 Bactria 2 3 4 5 6 7 8 9 10 11

Dukhtar-i-Noshirwan Khotan

Fondukistan LADAKH
Baminyan Begram
12 13 Kabul 14 Khyber Pass 15 16 17 18 19 20 21 22

Herat R. Kabul Peshawar Srinagar
AFGHANISTAN Hadda Taxila Avantipur KASHMIR H
 Gandhara I
23 24 25 26 27 28 29 30 31 32 33 M T I B E T

Jammu Kangra A Lhasa
PUNJAB Lahore L Gyan-tse
Bolan Pass GARHWAL A Y
 Harappa A
34 35 36 Multan 37 38 39 40 41 42 43 44

BALUCHISTAN R. Indus Delhi NEPAL S
45 46 47 48 49 Mathura 50 51 52 53 54 55

Mohenjo-daro RAJPUTANA Jaipur R. Jumna Khatmandu
 Osia Gwalior R. Ganges Patan
Chanhu-daro Jodhpur
Karachi Pataliputra A
56 SIND 57 58 Mt. Abu 59 60 61 62 63 64 65 66 SSA
 Khajuraho Barabar BENGAL
 Udaipur Besnagar Bharhut Sarnath Nalanda
 Modhera Bhumara Benares Bodhgaya
67 68 69 70 Sanchi 71 72 73 74 75 76 77

 Bagh I N D I A Calcutta
Somnathpur Deogarh
 Ajanta Hills C
78 N 79 80 81 82 Ajanta 83 A 84 ORISSA 85 86 87 88

 Elura N Bhuvanesvar
 Nasik Komaraka
Bombay Karli D
Elephanta A
91 Bhaja 92 93 94 95 96 97 BAY 98 OF 99

 Bedsa BENGAL

Ahmadnagar 93 Aihole R. Kistna Amaravati
Amaravati 106 Badami Pattadakal
Ajanta 93 102 103 104 105 106 107 108
Alchi 29
Avantipur 27 Vijayanagar Sigiriya 150
Assam Corridor 66 Sirohi 81
Basohli 38 Somanatha 80
Bengal 77 111 115 D 116 E 117 118 119 Spiti 29
Bhimnagar 39 Srinagar 27
 Madras Udaipur 70
Bilaspur 39 Garhwal 39 Kancipuram Vasali 75
Bijapur 104 Ghazni 24 Halebid Mamallapuram Vijayanagar 115
Bodhgaya 75 Golconda 105 Nilgiri
Bundi 71 Guge 16 Hills
Chawand 71 Gujarat 80 125 126 127 128
Chitor 71 Guler 39
122 Daulatabad 93 Hyderabad 105 Srirangam Kashmir 28 Mathura 61
Delhi 50 Jammu 38 Tanjore Kanauj 62 Mewar 70
Elura 93 Jodhpur 59 Kishangarh 60 Nagarkot 39
Gandhara 25 Kangra 39 Madura Kotah 71 Nalanda 75
133 134 135 136 137 138 139 Kulu 40 Nurpur 39
 Lapakshi 127 Orissa 97 143
 Magadha 63 Panamalai 127
 Malwa 71 Puhar 127
 Mankot 39 Quandahar 23

144 145 146 147 148 149 150 151 152 153 154
 Colombo
 CEYLON

Western Ghats

DECCAN